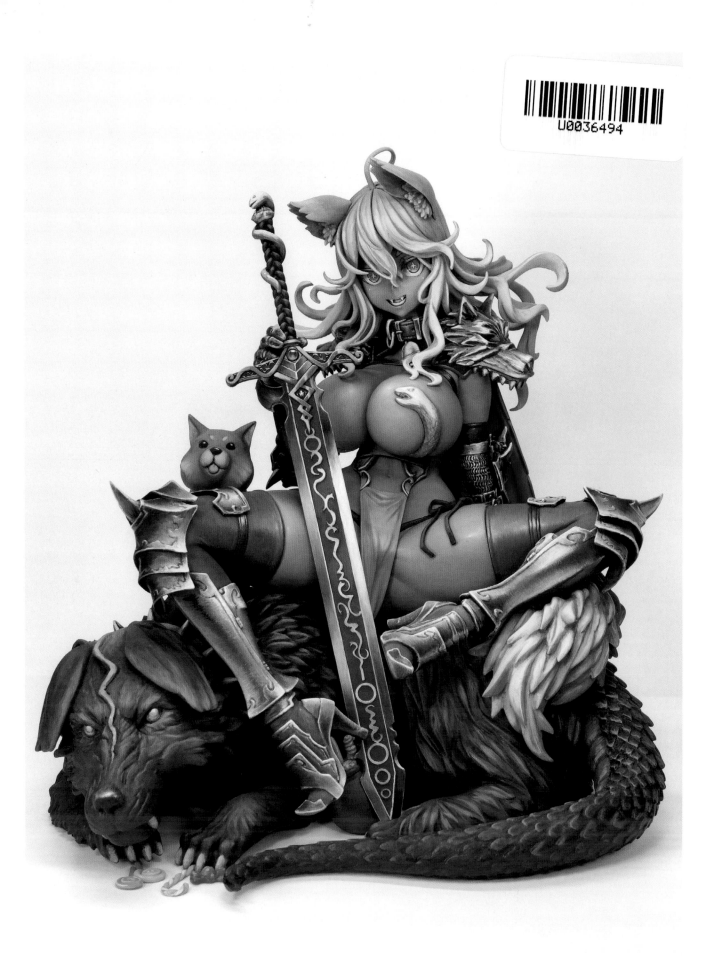

村上圭吾人物模型塗裝筆記

作者　村上圭吾

Contents

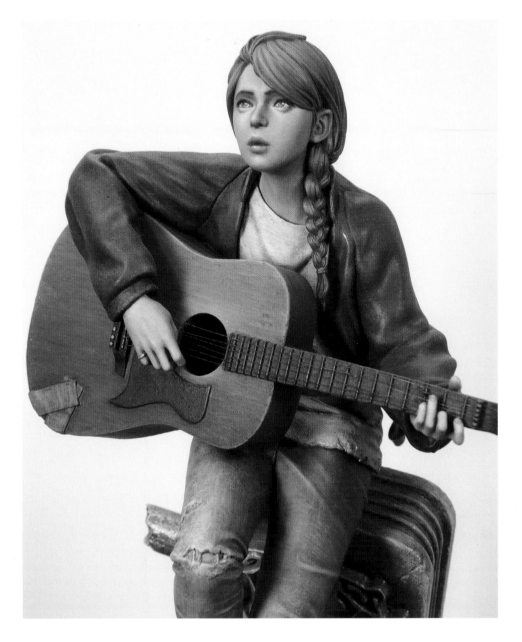

introduction

　　村上圭吾是非常受到日本國內外歡迎的人物模型塗裝師。本書是一本以記錄的形式，逐日觀察他描繪人物模型塗裝技巧的筆記。對於現在手上已經有這本書的各位讀者，我們可能無法保證，即便大家在徹底翻閱這本書的每一頁之後「塗裝技巧就會突飛猛進」，但是各位可以透過觀看他的風格、塗裝速度，還有驚人的創作數量，進而了解村上圭吾的所有面向。他認真看待塗裝製作，專心致志、創作不輟，持續追求進步的熱情，其秉持的態度才是真正提升塗裝水準的捷徑，而這些正是我們希望透過這本書傳遞給讀者大眾的內容，也就是村上圭吾的真實樣貌。

Keigo Murakami is a popular figure painter in both Japan and abroad. This book is a day-by-day "memorandum" of his figure painting techniques. Reading this book thoroughly won't guarantee that your painting skills will improve. However, it will give you a clearer idea of who Murakami is, what his painting style is like, and why he can paint each figure at astonishing speed. Dozens of his works showcased in this book show Murakami's dedication to his craft and his strong desire to keep improving without taking shortcuts. Murakami wishes to convey his unmatched passion for painting figures through this book.

survival:05　singer
2021年製作　無比例
原型製作　大畠雅人

作品精彩表現出樸質女孩與末日餘生的對比氛圍。服裝的質感表現也很值得大家細細品味。吉他的琴弦是利用船艦模型使用的釣魚線模擬重現。

The main theme of this sculpture is the contrast between the female protagonist and the dystopian background. The textural expression of the clothing is also noteworthy. Guitar strings are made from thin nylon cords used for ship models.

村上圭吾的簡介與經歷

頂尖人物模型塗裝師村上圭吾透過書籍和SNS，展示了色彩細膩又豐富的作品，吸引許多模型師的目光。除了日本國內，還有很多國外粉絲藉由SNS接觸到他的作品，其中西班牙的塗料廠商AK Interactive還推出了村上圭吾SIGNATURE模型塗料套組，如今村上圭吾已是深受矚目的日本塗裝師之一。

但令人意外的是，村上圭吾的模型相關經歷相當資淺。年幼時曾想要『鋼彈模型』而央求父親購買，不過收到父親購買的模型卻是『重戰機L-GAIM艾爾鋼』的塑膠模型。此後並沒有特別接觸塑膠模型，青少年時期玩過的模型大概就是迷你四驅車的改造。當時他相當熱衷動畫和漫畫，尤其喜愛庵野秀明的作品。而再次接觸模型則是因為『少女與戰車』，接著就從戰車模型開啟了模型製作之路。當時雖然也使用硝基漆塗料作業，但不知不覺慢慢轉為使用Vallejo水性漆。後來因為製作『Maschinen Krieger』而接觸到人物模型，然後就完全沉迷在人物模型塗裝的世界

中。自此主要將重心放在胸像模型或樹脂製的人物模型塗裝，至今仍以每年20～30件作品的驚人速度，享受人物模型塗裝的樂趣。

如此沉浸於塗裝的村上圭吾至今未曾就讀美術系的學校，也未特別學習美術相關課程，然而如前面所述，他對於漫畫和插畫有極大的興趣。尤其喜愛也有推薦本書的漫畫家木城幸人。另外，自己有興趣的插畫家，不論是在日本國內還是在國外的創作者，他都會直接和對方連絡並且購買其作品。最近他很喜歡的創作者是一位英國的插畫家Christopher Lovell（Instagram: @lovellart）。據說村上圭吾的塗裝作品發想，其實來自插畫或漫畫。他的作品充滿魅力，其中一個秘密就是，除了模型，他也會從別的領域獲取靈感。

Keigo Murakami is a top-class figure painter who has attracted worldwide attention with his delicate yet vivid style. AK Interactive has recently released a paint set with Murakami's signature colors, and he is currently one of Japan's most well-known creators.

Surprisingly, Murakami has a short history as a figure painter and creator. When he was a child, Murakami begged his father for a Gundam model kit (His father ended up buying him an L-Gaim, another famous Japanese robot-animation plastic model). Shortly after this incident, Murakami's interest shifted toward mini 4WD cars, animation, and cartoons. Murakami mentions Hideaki Anno's works as his favorites. He eventually returned to scale modeling after watching an anime about tanks. At the time, Murakami preferred using lacquer-based paints. However, that gradually shifted towards water-based or acrylic paints such as Vallejo. A few years later, Maschinen Krieger (and its figures) exposed Murakami to the world of figure painting. He moved his focus to painting bust models and resin figures and now paints up to twenty to thirty figures yearly.

In contrast to many other creators, Murakami has never graduated from an art school or studied art in any special way. However, as mentioned earlier, his interest in comics, animations, and illustrations was always high. He says Yukito Kijo is one of his favorite comic artists. Murakami doesn't hesitate to purchase artworks he likes, even from abroad. Most recently, he has been interested in Christopher Lovell (Instagram: @lovellart) works. When painting figures, Murakami gets inspired heavily by his favorite artists and comics. Gathering inspiration from different genres of creativity is one of the key factors that makes Murakami's works attractive.

木城幸人（Kishiro Yukito）／1967年出生於東京都，為一名漫畫家。1984年高中三年級時，以科幻漫畫『氣怪』參加第15屆小學館新人漫畫大賞並且獲得入選，而正式在商業雜誌出道。1991年起在集英社「Business Jump」連載正宗的賽博龐克漫畫鉅作『銃夢』。1995年連載完結後，於2000年開始連載續集『銃夢Last Order』。2014年起在講談社「Evening」連載系列最終章『銃夢火星戰記』。『銃夢』目前已經於全球18個國家翻譯出版，獲得世界各地熱烈的反響。而且還製作成電影，並且由好萊塢名導演詹姆士・卡麥隆負責監製，於2019年正式推出電影『艾莉塔：戰鬥天使』。

PROFILE

日本頂尖塗裝師，1978年出生，現住愛知縣，以驚人的速度製作高品質的人物模型塗裝。不但透過 SNS 積極發表作品，還會舉辦人物模型塗裝會與工作坊，最近更活躍於作品塗裝以外的活動，例如舉行線上塗裝直播。

Born in 1978. Currently resides in Aichi Prefecture, Japan. He is one of the leading figure painters in Japan, producing high-quality works at an astonishingly fast pace. He frequently hosts workshops and online painting sessions and remains active in many fields.

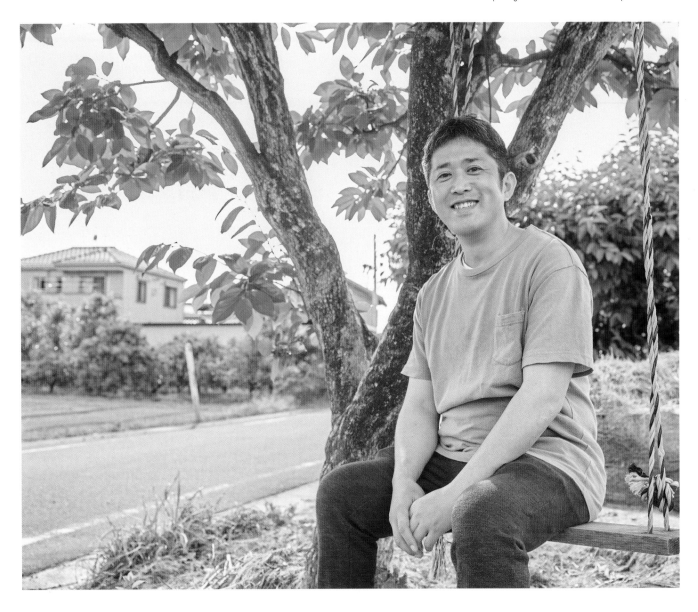

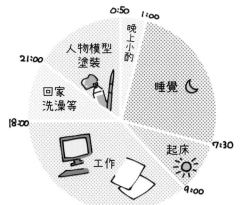

村上圭吾的一天
A day of Murakami's life

　　這是村上圭吾平日大概的行程表。由於他是一名上班族，白天忙於工作，晚上才有自由的創作時間。晚上大概完成不到4小時的塗裝製作後，就會喝杯蘇格蘭威士忌或波本威士忌結束一天。星期六日不需要工作，所以通常會利用各半天的時間在塗裝製作。

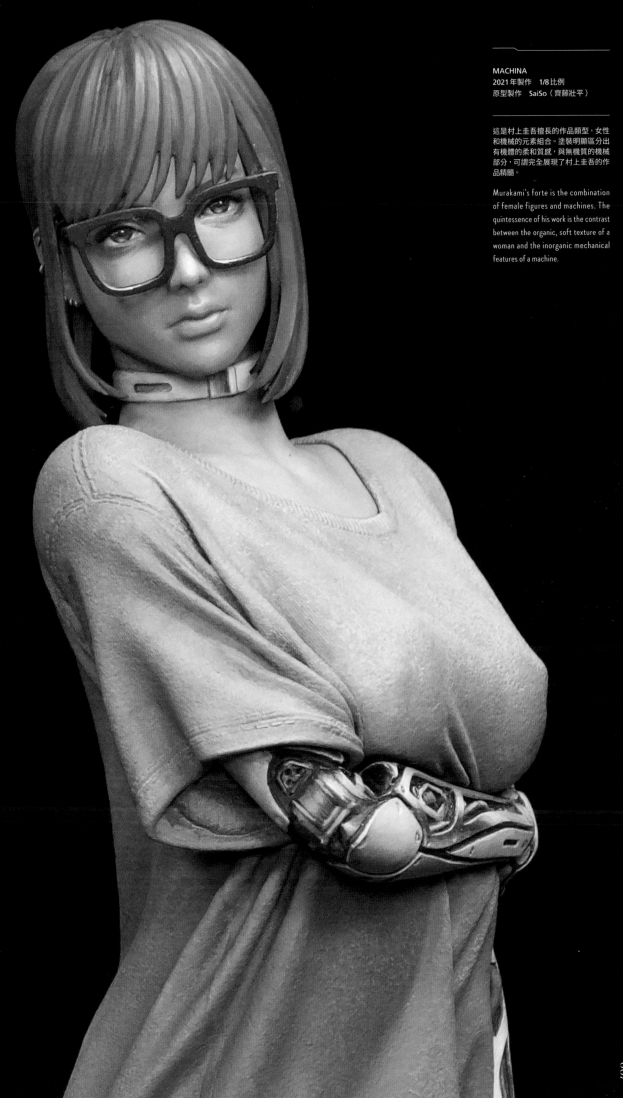

MACHINA
2021 年製作　1/8 比例
原型製作　SaiSo（齊藤壯平）

這是村上圭吾擅長的作品類型，女性
和機械的元素組合。塗裝明顯區分出
有機體的柔和質感，與無機質的機械
部分，可謂完全展現了村上圭吾的作
品精髓。

Murakami's forte is the combination
of female figures and machines. The
quintessence of his work is the contrast
between the organic, soft texture of a
woman and the inorganic mechanical
features of a machine.

村上圭吾的愛用品

⋘ 打底塗料 SURFACE PRIMER

不論是樹脂製品，還是塑膠成型套件，村上圭吾都喜歡用 GSI Creos 或 Vallejo 的罐裝噴漆為人物模型打底。若是比例較小或是較為精細的造型，則會使用噴筆噴塗上 Vallejo 底漆。即便相同的顏色名稱，每家廠商的色調都有些微的不同。

Regardless of the kit's material (both resin and injection plastic), Murakami uses GSI Creos and Vallejo spray cans as primers. He prefers to spray Vallejo's primer-surfacer with an airbrush when working on small-scale or delicate subjects. Each company's primers have a slight color difference despite having similar names.

⋘ 主要塗料 MAIN PAINTS

早期會使用 Vallejo 的瓶裝水性塗料，但是現在主要使用管狀的水性壓克力顏料，因為不論是極佳的顯色度，還是乾燥後的霧面質感都很令人欣賞。主要使用的管狀塗料為 SCALE 75 或 502 Abteilung，近來也會搭配使用 KIMERA COLOR 的瓶裝水性塗料。其實他並未堅持只使用水性塗料，有時也會配合想展現的塗裝質感，使用油畫顏料、硝基漆或琺瑯漆等塗料。

In the early days, Murakami used Vallejo water-based paints. He now prefers tubed water-based acrylic paints since they have an excellent vividness and matte texture after drying. His other go-to paint brands are Scale 75, 502 Abteilung, and KIMERA. Murakami also uses oil or lacquer/enamel-based paints, depending on the situation.

>>> 畫筆 PAINTING BRUSH

金屬盤上排滿的畫筆種類豐富多樣，包括面相筆、圓筆、平筆和乾刷筆。其中最喜歡使用的畫筆是，德國廠商 Da Vinci 達芬奇和微縮模型廠商 Bigchild 聯名的 MAESTRO 系列。而描繪關鍵之處時則會使用 AK Interactive 的西伯利亞紅貂毛筆。另外，乾刷筆也喜歡使用微縮模型廠商 ARMY PAINTER 製的畫筆。

Murakami uses a wide variety of painting brushes. His favorites are Da Vinci brushes made in Germany and Bigchild's Maestro series. He prefers using AK Interactive's Siberian-collinsky brushes for the most delicate job. For dry-brushing, Murakami uses a paint brush manufactured by Army Painter, another miniature-figure company.

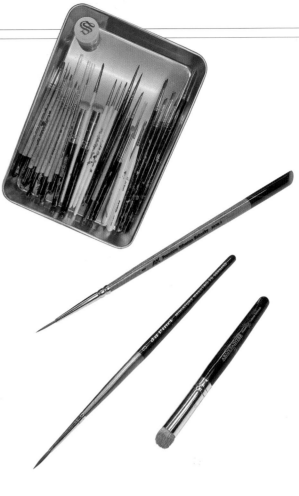

>>> 調色盤 PALLET

使用水性塗料時，尤其是管狀顏料，不可或缺的就是保濕調色盤。本體使用了尺寸較大的 RedGrass GAMES 調色盤，但是內層喜歡鋪墊的紙張並非原本的傳統紙張，而是替換成 Masterson ART 的紙張。其相比於原本的傳統紙張，較為厚實強韌，紙張不會吸附過多的水分，因此能很好地維持顏料的使用性。剛移至調色盤上的塗料，即便經過一段時間也不會太過乾燥，所以對於習慣塗裝時經常修改重塗的村上圭吾來說，這是非常重要的組合用品。另外他會在清洗畫筆用的保鮮盒底部鋪上一層擦拭紙。利用一點巧思，就可以在清洗多餘塗料時，盡量避免對畫筆造成傷害。

Wet pallets are essential when working with water-based paints (especially those tubed ones). Redgrass Games make the main body of the pallet, however, the inside sheets are swapped out with the ones by Masterson Art. These are thicker and sturdier than the original sheets, contributing to paints holding up longer over time. This is a very important modification for Murakami, as he prefers to work in the same area over a long period of time. The container for cleaning paint brushes has tissues (KimWipes) at the bottom. This is one of the techniques to minimize damaging the brushes while washing them.

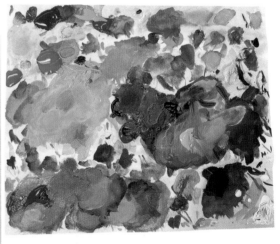

噴筆 & 空壓機
AIRBRUSH & COMPRESSOR

村上圭吾在基本塗裝的作業中主要使用畫筆塗裝，但是在打底塗裝等時候也會使用到噴筆。他手邊有一般噴筆，也有扳機式噴筆，但現在主要使用 ANEST 岩田的 HP-CH 噴筆。他希望今後在塗裝作業中也多多利用噴筆。

Despite brush painting being his primary method of coloring, Murakami also uses an airbrush for tasks such as base coating. He has traditional and trigger-type airbrushes in his inventory but currently mainly uses ANEST IWATA's HP-CH airbrush. Murakami hopes to incorporate airbrushes more into his figure painting.

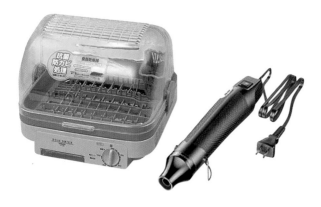

烘乾機 DRYING STATION

使用噴筆打底塗裝之後，為了避免沾染灰塵需放入烘乾機中。若真的不小心沾到灰塵，也會竭力小心翼翼地去除，不過想盡量避免這種情況發生。另外，塗裝作業中為了加速乾燥，有時也會使用熱風機。

After applying base coats with an airbrush, every part stays inside a drying station to prevent dust from adhering to the surface. You can remove dust after the paint drys, but Murakami prefers to minimize the risk of ruining the surface before starting to brush paint. Heat gun may also be used to accelerate the drying process.

塗裝支架 RETAINING JIG

為了放進前面所說的烘乾機中，會使用蜂巢狀的噴漆夾固定盒。描繪小件作品或零件的塗裝時，比較喜歡使用惑星屋 arco 的塗裝治具。他手邊備有各種尺寸，方便區分使用於不同的人物模型尺寸。

A honeycomb-shaped painting booth is used for storing parts in the previously mentioned drying station. A special retaining jig comes in handy for holding small subjects or tiny parts.

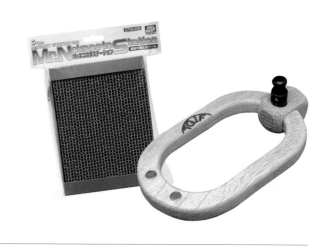

清洗用品 CLEANING AGENTS

塗裝完畢後也要注重畫筆的清洗保養。Da Vinci 達芬奇畫筆保養洗筆皂為固態肥皂狀，只要將沾水的畫筆滑過肥皂表面，就可以去除塗料。接著再用 Vallejo 的畫筆修復液，讓筆尖收聚一起，維持聚鋒度後，再放置收納處。

One must take care of their paint brushes after use. For this purpose, Murakami uses Da Vinci's cleaning soap. After rinsing off the excess paint, Vallejo's brush restorer is used to sharpen the brush tip.

≫ 實體顯微鏡 STEREO MICROSCOPE

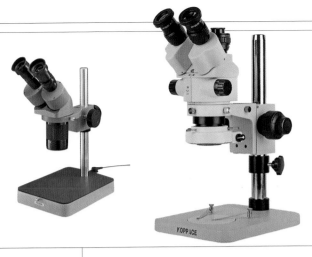

不只人物模型的臉部，連精細塗裝的作業，前述提到的灰塵去除等，都需要使用這個工具。三眼式（照片右邊）的規格也經常出現在塗裝直播或發布影片的拍攝中，幾乎大多都使用這種三眼式的顯微鏡。

A stereo microscope is an indispensable tool not only for painting faces but also for detail painting and removing specks of dust, as previously mentioned. The trinocular type, with the ability to mount a video camera, is beneficial for live demonstration/streaming.

≫ 超音波洗淨機
ULTRASONIC CLEANER

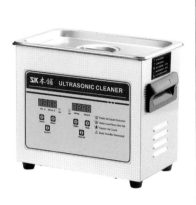

用於成型套件經過研磨之後的清理。但是村上圭吾最近也在思考，自己是否不需要過度擔心這些看不見的細小粉塵。

Used for cleaning model kits after extensive sanding sessions. Murakami recently realized that he might not have to worry about minuscule resin/plastic shavings that are invisible to the naked eye.

≫ 研磨用品 SANDING MATERIAL & ET CETERA

在修整套件時，主要使用道刃物工業Modeledge系列的雕刻刀，而且其實在去除灰塵方面，也是非常好用的工具。神之手的砂紙則用於套件的平整修飾。

The primary tool used for modifying resin/plastic surfaces is Michihamono's Modeledge blades. These are quite helpful for dust removable as well. For final prep work before painting, sanding sponges by God Hand comes in handy.

≫ 接著劑或補土等
GLUE & PUTTIES

處理樹脂製套件的細微氣孔時，會使用CYANON瞬間接著劑加嬰兒爽身粉。使用時，會將CYANON瞬間接著劑和嬰兒爽身粉混合在造形村紙調色盤的紙張上。樹脂製的零件黏合則使用HORIZING的Magic Sculpt環氧補土。

Combining cyanoacrylate (CA glue) with baby powder allows tiny air bubbles typically seen in resin kits to be easily filled. These two ingredients are mixed on a sheet of Zoukei-Mura's paper pallet. Magic-Sculpt by HORIZING is used to glue resin parts.

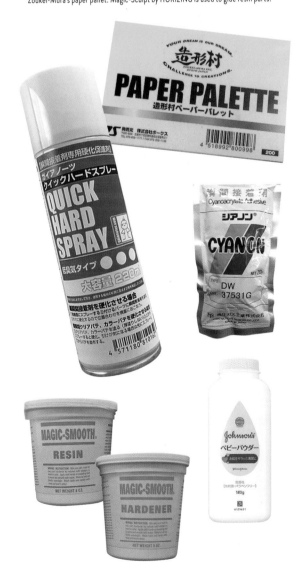

村上圭吾的工坊

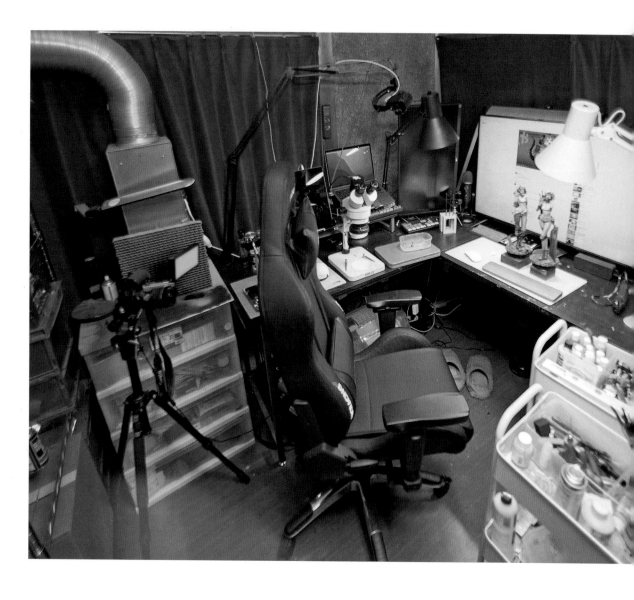

作業的空間配置出乎意料地簡單。L型的工作桌上架設了大型螢幕，用來確認資料或製作中途拍攝的照片。畫筆和塗料用品全都收納在有滑輪的推車，想要使用時可隨手取得。最講究的部分是照明，作業環境相當的明亮。

Murakami's working station is surprisingly simple. A large display (utilized for viewing reference materials) is mounted on an L-shaped working desk. Paint brushes and paints are placed inside a movable wagon for easy access (see page 13). The lighting is the most important feature, keeping the work environment very bright.

▼工作椅選用電競椅，極為穩定舒適。

The work chair is originally intended for gamers. The stability of these gaming chairs is outstanding.

◀為了作業中途的確認以及將作品上傳SNS，在拍攝上所需的單眼相機。

Murakami uses a aps-c DSLR camera for capturing work-in-progress photos.

▼補光燈裝備了高輝度且顯色性高的LED燈。

The camera is equipped with an LED light with excellent brightness and color rendering capability.

▼在居家用品店購買的推車中收納了使用頻率較高的塗料、稀釋液和塗裝治具等用品。因為有附滑輪，雖然體積較大卻不影響作業。

This wagon, purchased in a DIY store, holds frequently used paints, thinners, and retaining jigs. The wagon is equipped with casters, so it doesn't interfere with the work environment despite its large size.

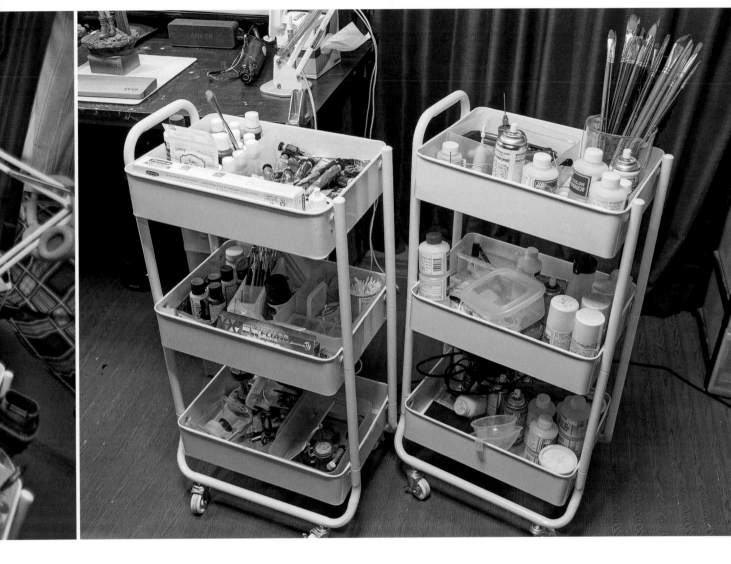

▶照明燈選擇了山田照明的Z型燈，目前設置了3台。

Three Yamada Shomei's Z-Lights act as a prime light source.

▶為了拍攝發布作品時的手邊作業，還在桌上放置了相機。

A camera is placed on top of the desk to capture close-up shots.

▲俯視攝影所需的支撐架，可靈活移動。

This mechanical arm swivels very smoothly and allows for an overhead camera angle.

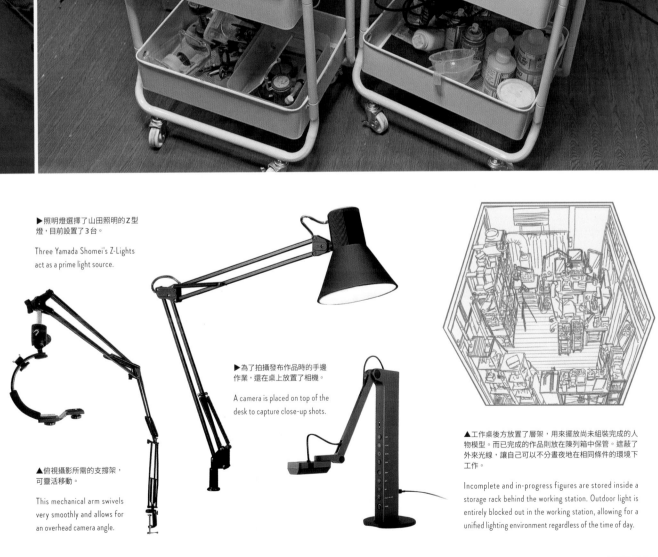

▲工作桌後方放置了層架，用來擺放尚未組裝完成的人物模型。而已完成的作品則放在陳列箱中保管。遮蔽了外來光線，讓自己可以不分晝夜地在相同條件的環境下工作。

Incomplete and in-progress figures are stored inside a storage rack behind the working station. Outdoor light is entirely blocked out in the working station, allowing for a unified lighting environment regardless of the time of day.

村上圭吾的塗裝研究

由村上圭吾塗裝風格創造的無數作品總讓人為之著迷，深深吸引住大家的目光。而且對於他的創作風格，不但無法以一言蔽之，更無法加以歸類。他的塗裝手法極為獨特，完全不同於所謂的歐洲塗裝或擬真人物模型塗裝。即便從技法層面來看，也並非國外軍事人物模型常見的疊色塗裝，更不像油畫般呈現混色暈染的柔和色調。雖然和速寫等使用的細線法質感類似，卻又不盡相同。而金屬部分雖是不使用金屬色的NMM（非金屬色金屬）技法，但是其發想和技法書中的描述卻又有點差異。總而言之，村上圭吾的塗裝是以現有語彙無法言喻與描述的世界。

我們曾多次採訪並且試圖分析他的塗裝技法，但也只能稱之為村上流塗裝，是一種獨一無二的塗裝風格。從暗色調打底（有時真的是全黑色調）開始塗裝，而且使用談不上具有高遮蔽力的水性壓克力顏料，甚至還加以稀釋，接著不斷反覆地淡淡重疊

上色。直到描繪出理想的顯色度，早已疊加了許許多多的筆觸，然而正因為如此，誕生了值得細細品味的塗裝質感。在顏色挑選方面也獨樹一格，衣服、盔甲、膚色中疊加了綠色、黃色、紅色和藍色等色調。這些在印刷上也令人膽顫心驚的用色，在他的作品中卻一點也不會讓人感到突兀。塗裝表面不單調、顏色疊加不簡單，他的作品中蘊藏了屬於村上流的玩心。

他在人物模型塗裝方面幾乎都是自學。不依賴技法書，每次依照自己想表現的作品挑選所需，再下筆描繪。另外他表示自己並未只使用水性塗料，而是只想描繪自己覺得有趣的人物模型塗裝。村上流塗裝的核心或許就在於「盡情沉浸於塗裝的樂趣」。

Alai The Templar's Atonement
2021 年製作　1/10 比例胸像
GARAPAGOS miniatures

作品中的女性給人樸質的感覺。盔甲等金屬部分並未使用金屬色，而是以NMM（非金屬色金屬）技法塗裝完成。

Metallic surfaces of this piece, such as those of armor plates, are painted using the non-metallic metal technique without any metallic colors.

Keigo Murakami's painting style has captivated many viewers. However, it is difficult to summarize his style in one word. His unique style is close to, yet distinctly different from the so-called European finishes. Surfaces painted by Murakami are nothing like the layer-based painting style seen on military figures, nor blending-base realistic figures using oil paints. It has a texture similar to that of hatching (an artistic technique used to create tonal or shading effects), but it is not the same. Murakami uses the non-metallic metal technique for painting metallic surfaces, yet even that has a different feel than those described in figure-painting technique books. In other words, you simply can not describe Keigo Murakami's painting style.

Even after repeated interviews with him, it was still impossible to categorize Murakami's painting style from existing ones. Starting from a dark (sometimes pitch-black) primer coat, Murakami patiently builds up colors layer after layer. It sometimes takes a hundred or so layers before the color reaches the intended brightness and vividness. This is what gives Murakami's painting style its iconic depth of feeling. The choice of colors is also unique. Unusual tones such as green, yellow, red, and blue are thrown on top of the skin tone without making the subject look unnatural. Each of Murakami's works is filled with his playful spirit, with non of them looking monotonous and boring.

Murakami is almost an entirely self-taught figure painter. He depends on no technique books, chooses what is necessary to achieve the expression he aims for, and then proceeds with his brush strokes. "I only want to paint the fun part," says Murakami. Maybe the key to understanding his style lies in the fact that he thoroughly enjoys painting figures.

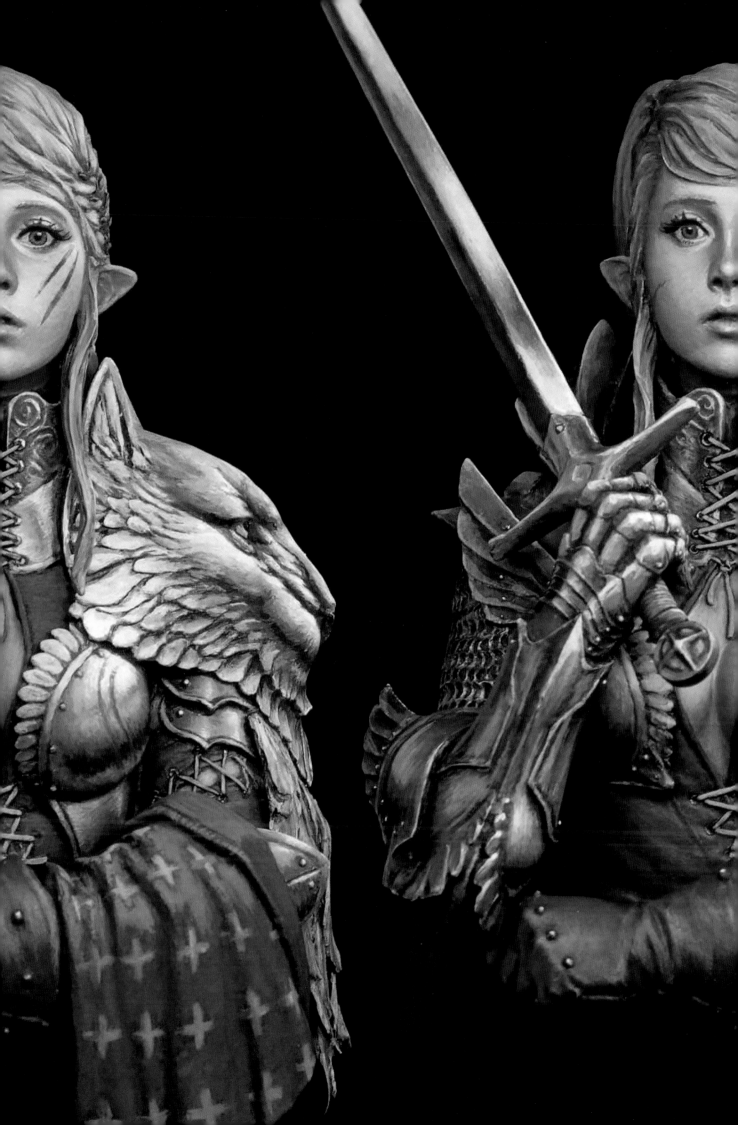

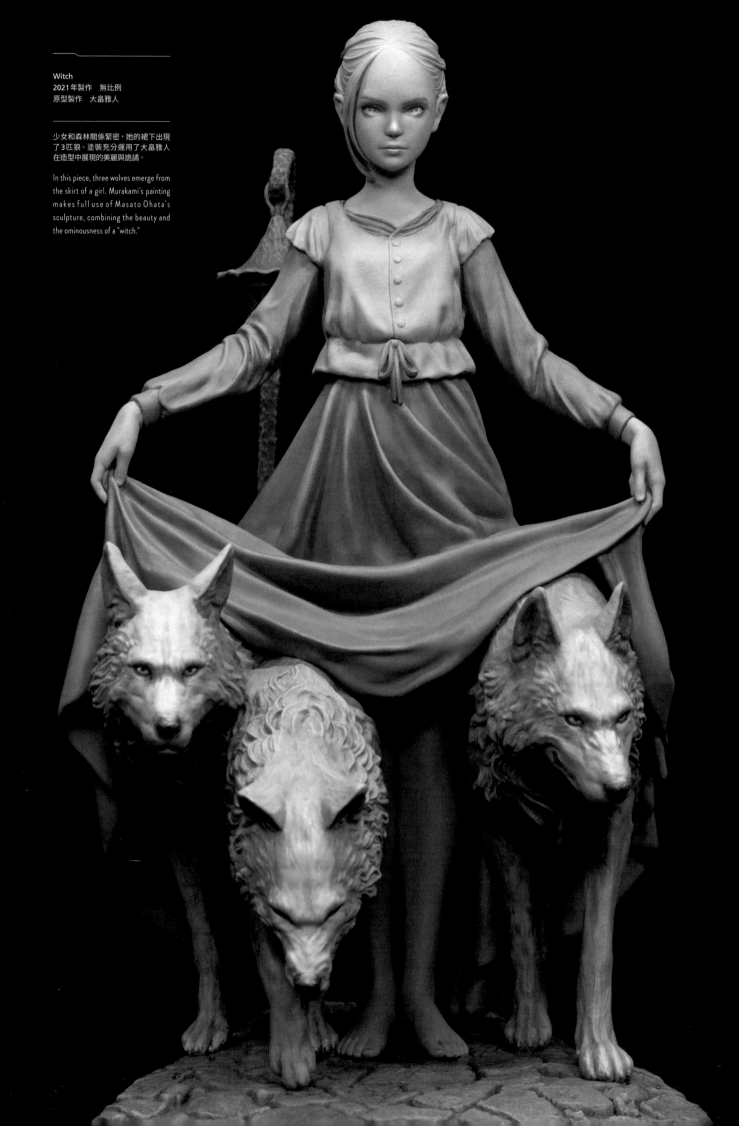

Witch
2021 年製作　無比例
原型製作　大畠雅人

少女和森林關係緊密，她的裙下出現
了3匹狼。塗裝充分運用了大畠雅人
在造型中展現的美麗與詭譎。

In this piece, three wolves emerge from
the skirt of a girl. Murakami's painting
makes full use of Masato Ohata's
sculpture, combining the beauty and
the ominousness of a "witch."

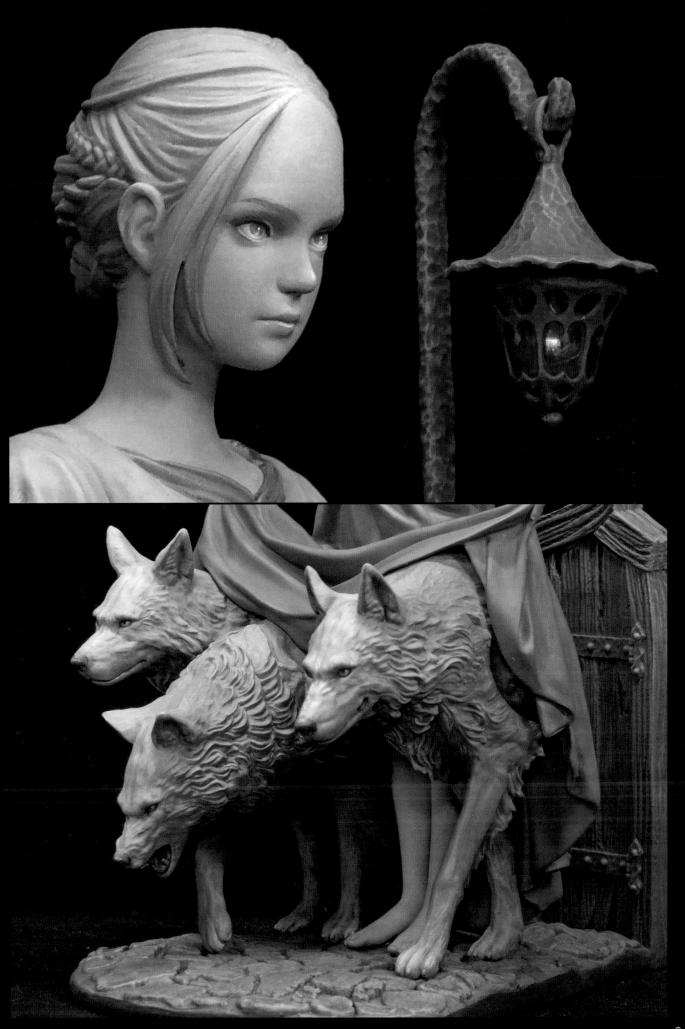

完
成
塗
裝
的
基
本
步
驟

01

修整套件零件的湯口，完成最基本的研磨作業後暫時組裝。零件表面有脫模劑殘留的部分，用清洗液浸泡後再用清潔劑洗淨。暫時組裝後，進入打底塗裝作業，尺寸大的零件用噴罐噴塗，細小纖細的零件用噴筆噴塗。

After sanding and prepping the parts, Murakami test fits the sculpture to check their overall condition. Some components may have some residue of release agents, so they are thoroughly soaked and washed with a cleaning solution. The first primer coat is applied using an airbrush, but Murakami also uses a can spray for bigger parts/surfaces.

02

先從肌膚部分和臉部開始塗裝。畢竟臉部是作品中最重要的部分，也是在有限的塗裝時間中最想多花時間描繪的部分。一開始會花較多的時間在臉部和眼睛，希望能夠高度提升人物樣貌的精細度。

The painting process begins with the skin. The face is obviously an important feature of a sculpture. With the limited time he has, Murakami spends as much time as he can on painting the face. Taking extra care of critical components such as the eyes is essential to achieve the depth of detail Murakami is after.

03

完成臉部和肌膚的精細度後，再繼續描繪其他部分。除了服裝和小配件，也一次描繪其他的元素、構成背景的地面或配角。為了讓大家將視線集中在臉部，刻意不提升其他部分的精細度。

After finishing the face/skin, the rest of the sculptures, such as the clothing and accesories, can be painted. Background and other sub-elements are also painted accordingly. You want the viewer's attention to the main subject (and its face), so Murakami is careful not to add too much detail to other components.

04

確立整體樣貌後，用單眼相機拍攝，並且在螢幕上確認照片。挑出不滿意的部分並且調整修飾。只要時間許可就會不斷反覆這個步驟。其實到了最後，都在修改不仔細看就看不出的部分。

Taking a photo and checking the images is a valuable method for checking your overall progress and the quality of your painting. Any area that looks odd is identified and re-touched. This process is repeated as long as time allows. These corrections are so minuscule at the very last stages that it's hard to tell just by looking at the before/after pictures.

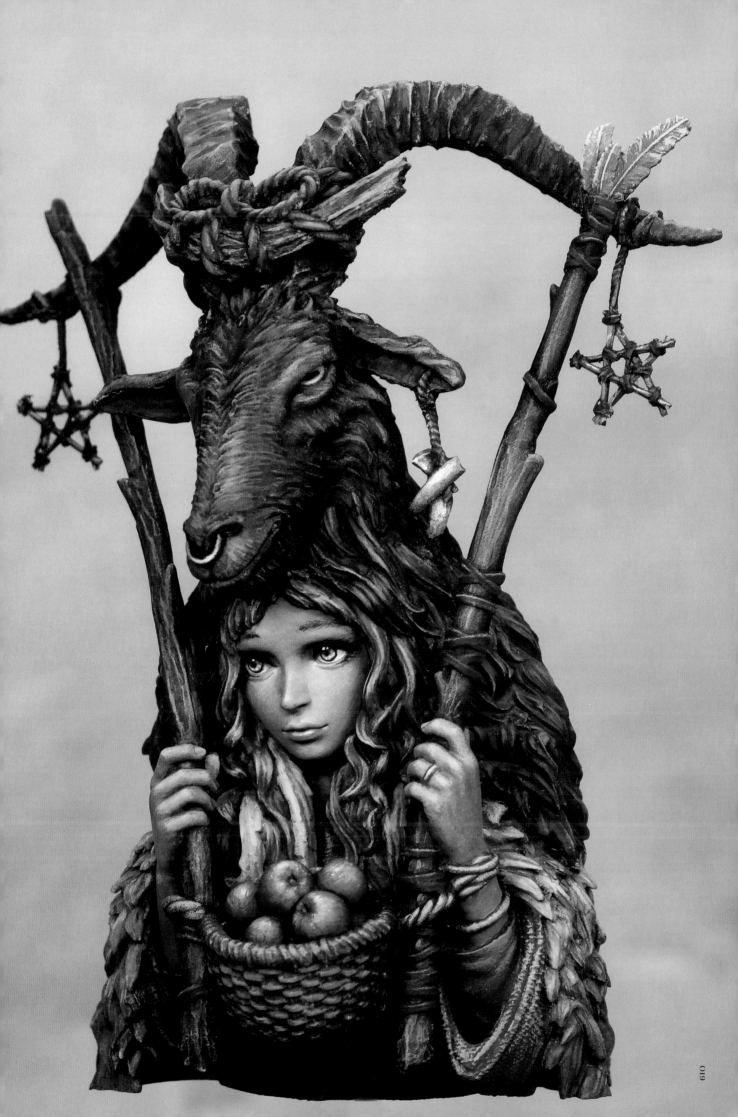

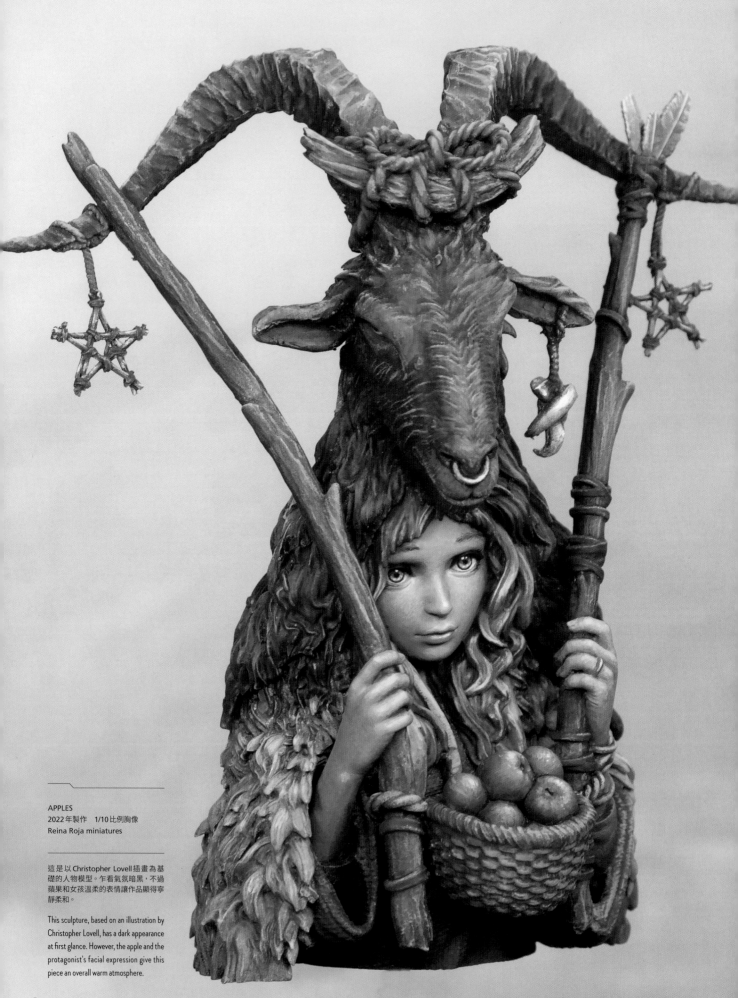

APPLES
2022 年製作　1/10 比例胸像
Reina Roja miniatures

這是以 Christopher Lovell 插畫為基礎的人物模型。乍看氣氛暗黑，不過蘋果和女孩溫柔的表情讓作品顯得寧靜柔和。

This sculpture, based on an illustration by Christopher Lovell, has a dark appearance at first glance. However, the apple and the protagonist's facial expression give this piece an overall warm atmosphere.

村上圭吾的10分鐘

▲在組裝好所有零件的狀態下開始塗裝。打底塗裝（黑色 →灰色）完成後，開始著手肌膚的塗裝描繪。

Painting begins after assembling all components. Grey primer is applied on top of black prior to painting the skin tones.

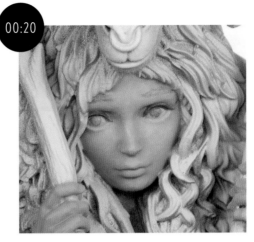

▲臉部已大概塗裝的狀態。描繪了大概的視線，正慢慢勾 勒出整體的輪廓。

The face paint is still in rough form, and the eye lines are also only temporal. This is when you start building up the overall image of the final finish.

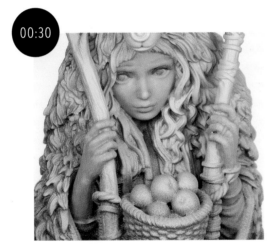

▲漸漸在肌膚重疊上色，加深色調（讓肌膚色調更加明 顯）。

The color of the skin is applied little by little. As the layer builds up, the vividity of color gets thicker (and brighter).

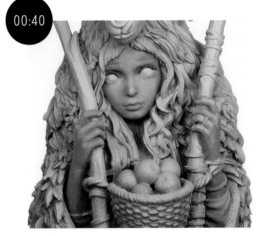

▲大概完成膚色部分的陰影塗裝。在膚色重疊上色，一點 一點塗上藍色和黑色。

Rough stage of painting the shadows of the skin. A small amount of blue and black is added to the skin tone and applied to desired areas.

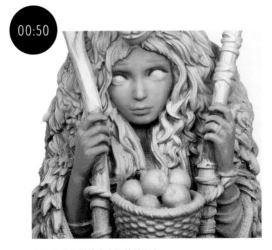

▲持續重疊描繪出大概的陰影色。

Rough painting of the skin's shadows continues.

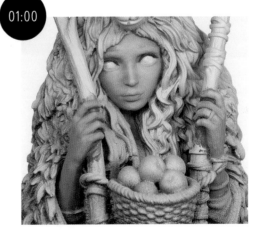

▲暈染陰影色的交界，並添加一點紅色調。

The previously applied shadows are blended together, and a tint of red is added to the skin.

詳細研究村上圭吾的塗裝技巧，一天完成整體作品的 6 成

村上圭吾在作業速度上也是公認的快速。
這件作品我們決定請他每 10 分鐘按一次快門記錄，以確認塗裝上有甚麼變化。

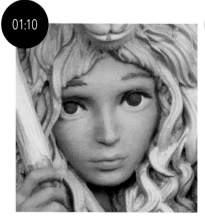

01:10

▲一邊在臉部周圍重疊上色，一邊進入眼睛描繪的作業。先大概勾勒出眼周和眉毛等部位。

The painting of the eyes begins by roughly drawing the outlines and eyebrows.

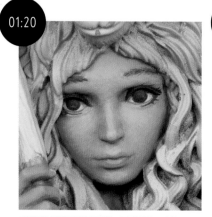

01:20

▲調整睫毛等眼睛的周圍塗裝。開始慢慢添加打亮。

The outlines and eyebrows are further refined, and painting of the highlights also begins.

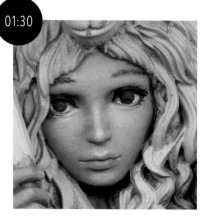

01:30

▲開始描繪眼睛的細節。一邊構思視線的表現，一邊決定黑眼珠的位置。

Next is painting the pupils. This will determine the line of sight of the figure.

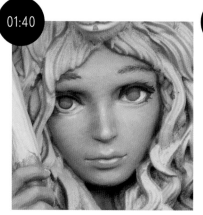

01:40

▲持續描繪眼睛細節。小心在內側塗上藍色。

The eye painting continues. The inner blue-hue of the pupils are drawn in.

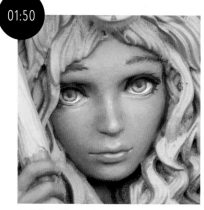

01:50

▲接著在眼睛描繪的作業中，描繪出眼睛的打亮部分，畫出瞳孔的細節。用充足的時間描繪眼睛的部分。

The highlights of the pupils are painstakingly painted on. No time should be spared here.

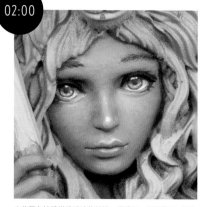

02:00

▲依舊在持續描繪眼睛的細節。描繪至一定程度後，再次調整膚色的打亮。

There is still a lot more to be done with her eyes, but the focus shifts to painting the highlights of the skin.

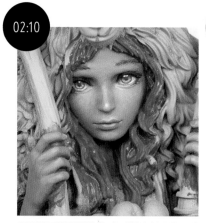

02:10

▲開始進入頭髮的塗裝作業。為了描繪出金色頭髮，先從打底塗裝開始。

Painting of the hair starts by applying the appropriate base color. This one will be painted as a blondie.

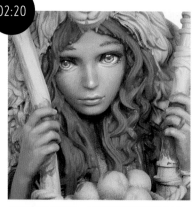

02:20

▲頭髮大概塗裝的樣子。從最深的陰影色開始重疊上色。

An early phase of the hair painting. Start by applying the darkest shadow-tone of the hair color.

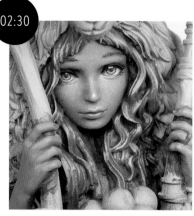

02:30

▲一邊在頭髮添加打亮，一邊完成大概的髮色塗裝。

Painting the first highlight color of hair. Try not to spend too much time here, as this is only the rough stage of the whole painting process.

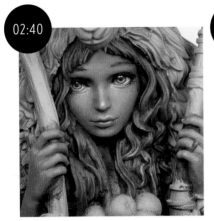

▲由於整體的頭髮顏色已暫時定調，所以用一開始塗的顏色，厚塗漬洗。

To blend the highlights and the shadows, a thick wash of the base hair color is applied all around her hair.

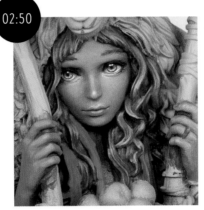

▲漬洗後，再次進入頭髮打亮的作業。

After the wash dries, the hair highlighting process resumes.

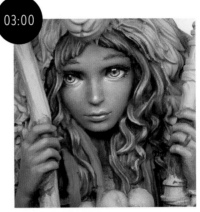

▲持續描繪頭髮，並且調整臉部的打亮。另外，也要同時處理手指部分的打亮等細節描繪。

To continue painting the hair, and adjusting the face. In addition, detail work such as the highlighting of her fingers are also done at the same time.

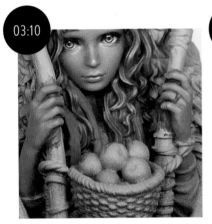

▲接著進入手指和手的塗裝描繪。

Her hands and fingers painting is further refined with more layers of highlights and shadow tones.

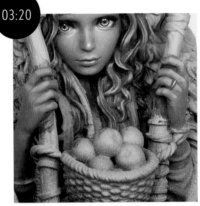

▲繼續描繪手指。慢慢地呈現出有立體感的塗裝。

After several detail-painting and blending sessions, her hands look more natural.

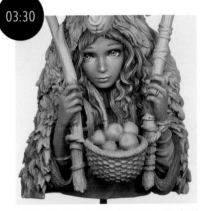

▲終於要開始描繪衣服的塗裝。原型的紋路相當細膩，所以用淡淡的塗料如染色般輕輕塗色。

Finally, the painting process of her clothing begins. Since this particular sculpture has crisp detail, the base coloring of the clothing can be done easily with the use of thinly diluted paint.

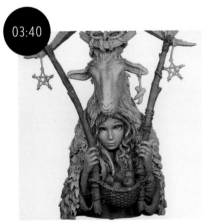

▲接下來描繪兩手握住的木棒、籃子和籃子中的蘋果。如服裝塗裝一樣用淡淡的塗料上色。

Other components, such as the basket, the apples inside it, and the two sticks she is holding, are painted using the same technique as her clothing, with thinly diluted paint and staining.

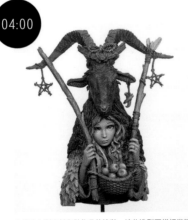

▲進入大型山羊和裝飾品的塗裝。這些造型同樣相當精緻。用黑色和膚色混合後為山羊塗裝。

The large goat ornament and the rest of the small details are painted. The goat receives a base coat with a mixture of black and skin color.

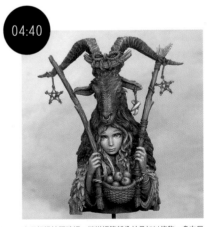

▲用相機拍照確認，端詳細節部分並且加以修飾。多次反覆這項作業並且修飾整體的塗裝直到完成。

After taking several pictures of the figure, small corrections can be made. These steps are repeated numerous times until all the errors are sorted out. This piece is now completed!

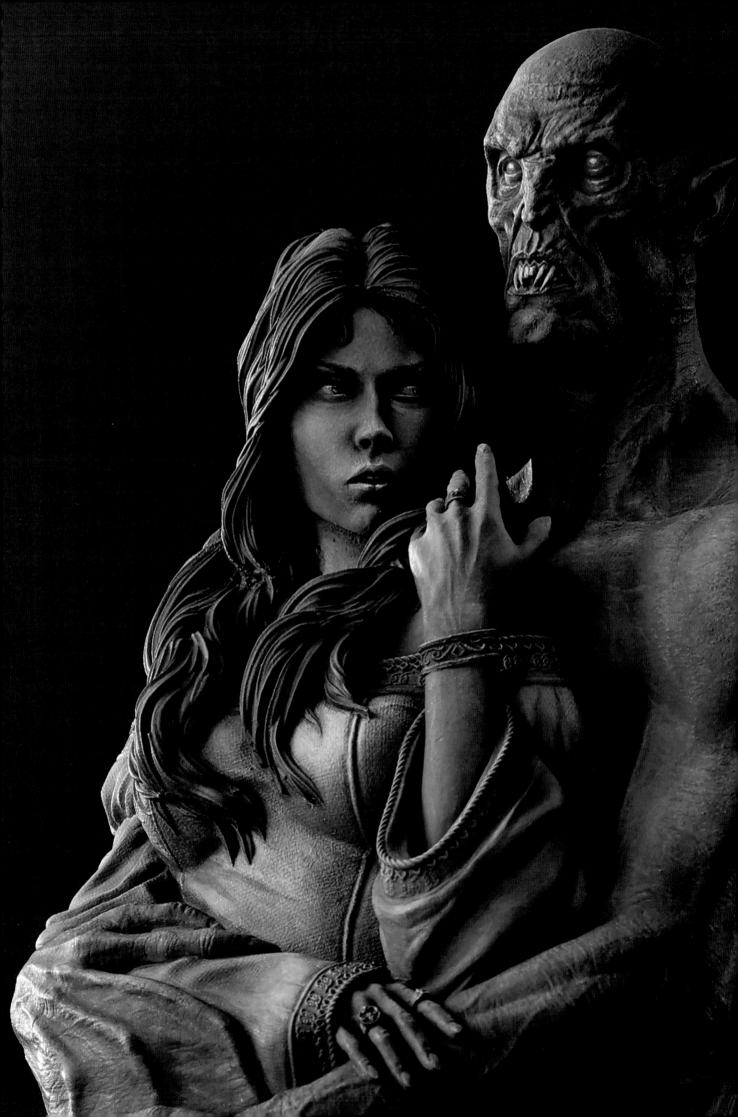

Beauty & Beast

美女和怪物的盛宴

村上圭吾作品因樸質的女性塗裝而大獲好評，但其實他在怪物的塗裝技巧也不容忽視。
美麗的女性和不祥的怪物，作品中以非常協調的塗裝展現兩者的組合。

Day.1

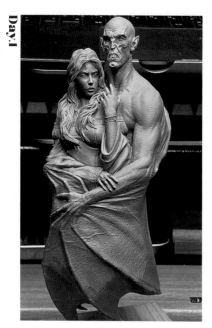

▲套件分成6個零件，先將全部組合後再開始塗裝。先為整個套件打底塗裝，用色調較深的灰色底漆補土塗裝，接著再從光源方向噴塗亮灰色的底漆補土。大概噴塗至看出套件紋路即可。

The kit is divided into six parts, all of which are assembled before painting. First, the entire piece is primed using a light grey surfacer, followed by an even brighter tone of grey sprayed from the direction of the light. This step also accentuates the details of the sculptures.

Day.2

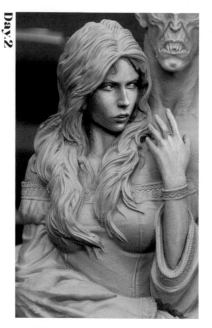

▲在女性的臉部和手臂等肌膚部分上色。肌膚用SCALE75（以下簡稱SC）的粉膚色、淺膚色、焦褐色混合上色。一邊為臉部大概上色，一邊決定視線，同時進行作業。

The painting of Beauty begins by applying skin color to her face, body, and arms. The skin is painted using a mixture of Scale 75's (SC) Pink flesh, Light skin, and Burnt skin. While roughing out the face and other parts of her skin, her eye's line of sight is determined simultaneously.

Day.3

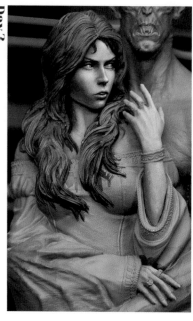

▲在剛才的膚色添加SC的藝術白在膚色添加打亮。一邊持續描繪，一邊調整所有肌膚部位的色調。

With SC's Art white added to the base skin color, the highlights of Beauty's skin are painted on. This is also an excellent time to apply minor corrections to her overall face and skin.

Day.4

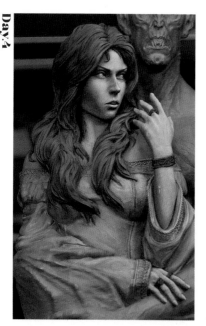

▲在肌膚描繪至大概的階段後，進入頭髮以及服裝的塗裝作業。不論是頭髮還是服裝都先從最暗的顏色開始重疊上色。

After making some progress on the skin, the focus shifts to her hair and garment. Both are painted starting from the darkest color.

Day.5

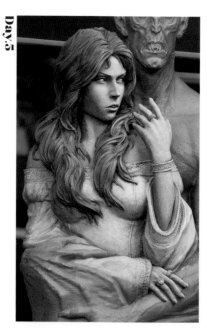

▲接著重疊上色描繪打亮。利用精緻的紋路，用細膩地運筆持續描繪。另外，同時描繪戒指和手環的金屬部分。金屬部分的塗裝並未使用金屬色，而以NMM（非金屬色金屬）的技法描繪。此外，在這個階段時，還要用SC的暗群青添加陰影。

To make the most out of the detail-rich sculpture, sensitive brush strokes are used to apply the highlights. Rings and bracelets are painted with a non-metallic metal technique. SC's Dark ultramarine was used to add the shadows.

Day.5

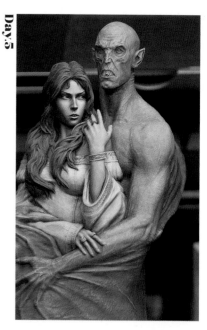

▲進入怪物部分的塗裝作業。由於人物模型的紋路相當精緻，利用這一點添加淡淡的塗料上色。使用SC的緋紅色和暗群青混合上色。

Since the Beast is littered with delicate surface details, paints were thinly diluted so as not to lose any of said details. His base color is a mixture of SC's Crimson and Dark ultramarine.

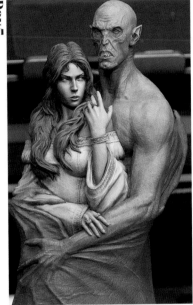

Day.5

▲極度稀釋前一個步驟中的混色，利用漬洗的技巧如染色般為整體塗裝上色。乾燥時利用熱風槍作業。

The base color described in the preceding step is diluted very thinly and applied as a wash as if staining his entire body. A heat gun was used to speed up the drying time.

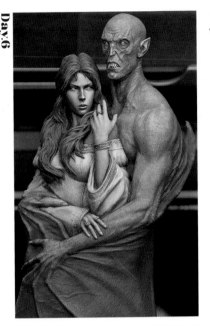

Day.6

▲為了區分翅膀部分和本體的顏色，添加更多的筆觸。翅膀部分用SC的焦赭色和緋紅色混合上色。為了描繪象徵怪物特色的眼睛，上色時描繪出猶如發光的塗裝表現。

Add more brush strokes so that the wings and the body of the Beast have a different texture. The wings received an additional layer of SC's Burnt sienna and Crimson. The eyes (and their surroundings) of the creature were painted to give them a glowing effect.

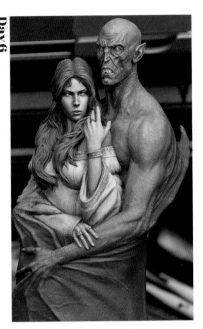

Day.6

▲利用細膩精緻的紋路，小心翼翼地運筆，以乾刷重疊上色。反覆漬洗和乾刷，完成怪物的塗裝。

Again, the dry brushing technique was used repeatedly to make the best of the delicate surface details. Painting of the Beast is finished by going back and forth between applying washes and dry brushing.

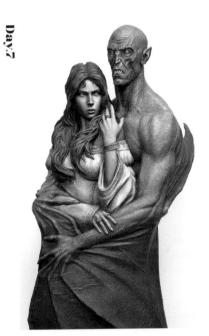

Day.7

▲用相機拍照、確認照片，並且調整怪物的色調和打亮。

Take a photo using a DSLR camera, check for errors, and adjust the two figure's colors and highlights accordingly.

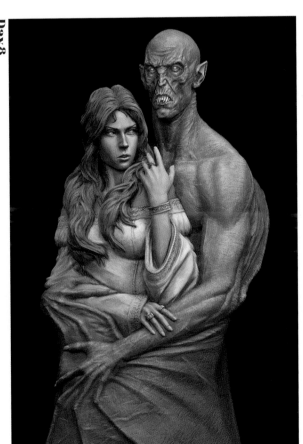

Day.8

◀從這個階段開始反覆拍照、確認、修改，預留充裕的時間反覆這道作業直到完成。

From this point on, the process of taking photos, checking for errors, and correcting them, is repeated until the piece is completed.

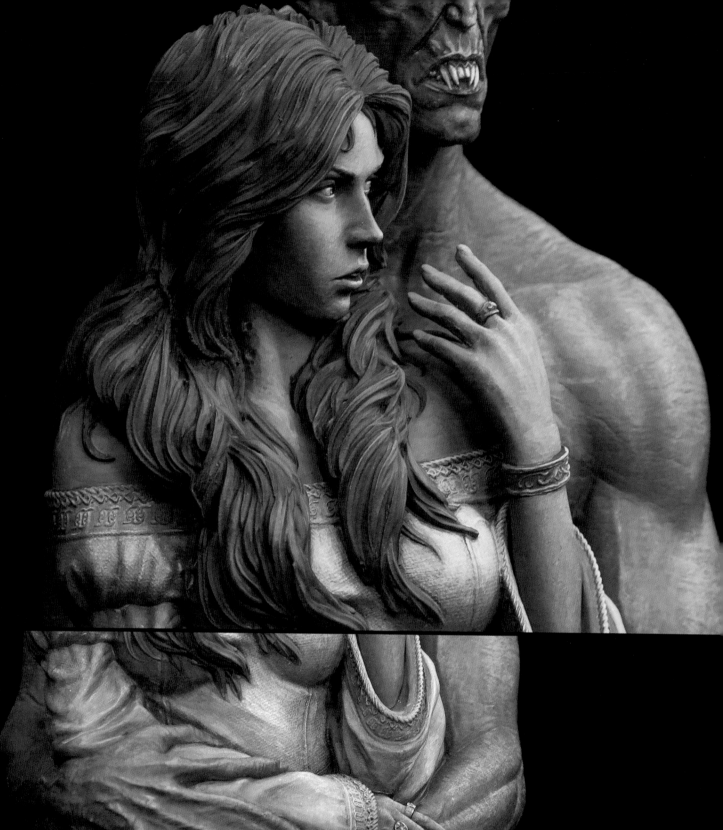
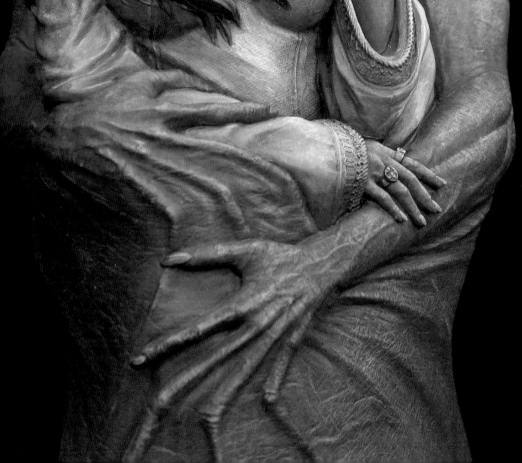

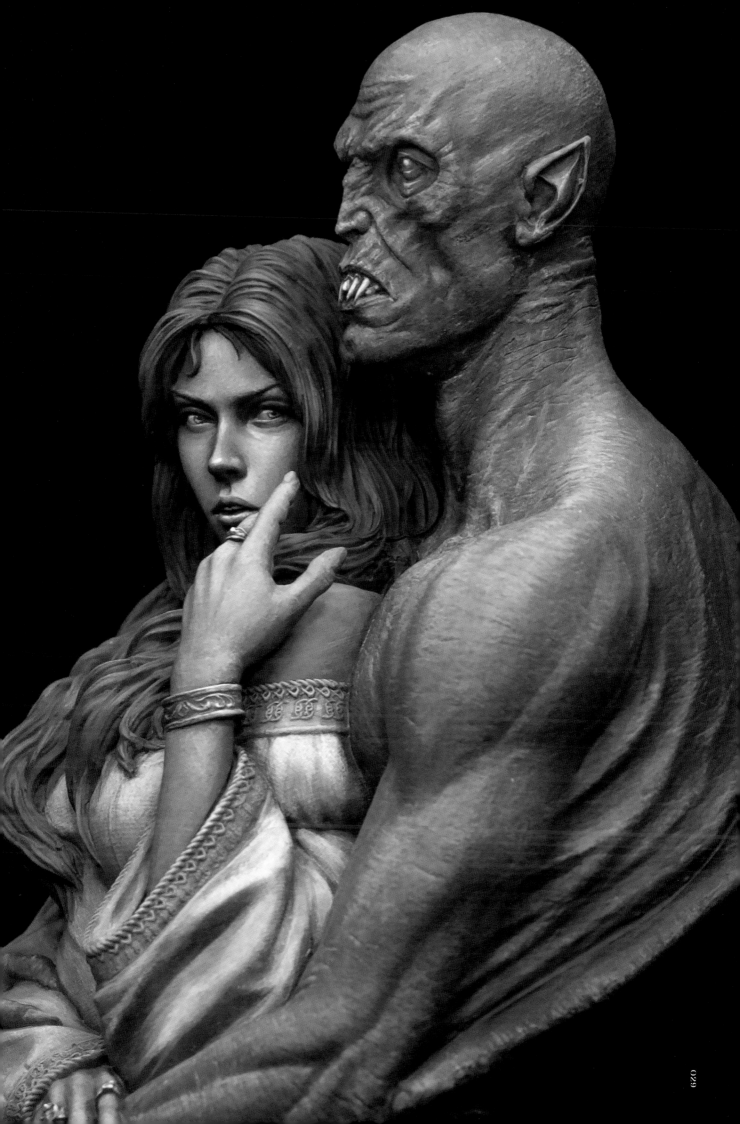

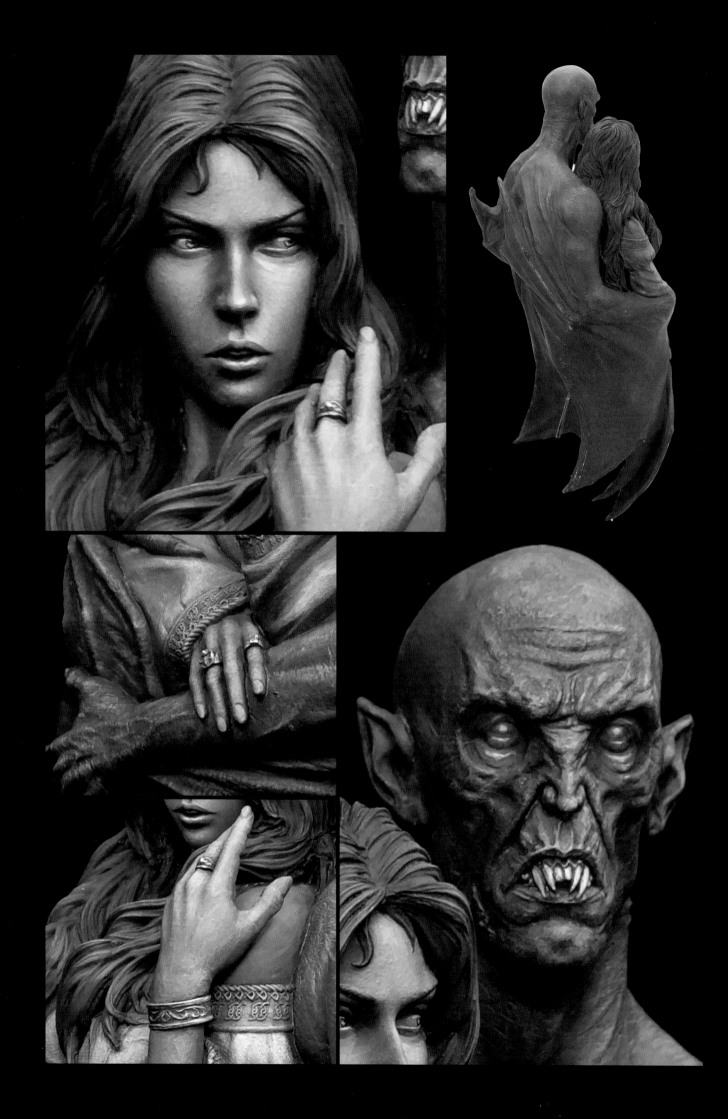

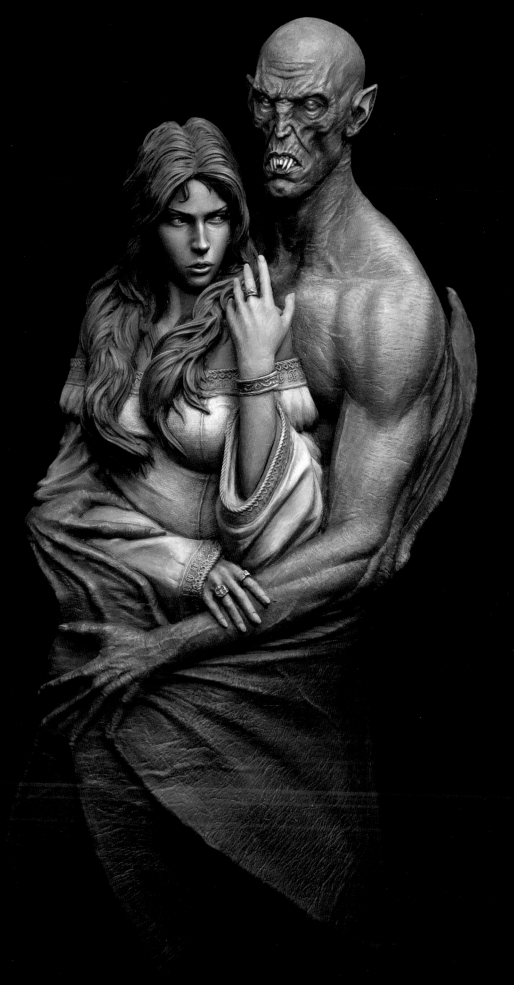

Beauty & The Beast
2022 年製作　1/10 比例
karol rudyk art

即便是奇幻作品依舊可以看出村上流
塗裝的實力。除了美麗的女性，連環
抱其身後的怪物，都散發著神秘的生
命力。

Murakami's painting style shows its
true value when applied to fantasy
sculptures. In addition to the woman's
beauty, the monster that embraces her
also possesses a mysterious presence.

BORDER HUNTER GIRL

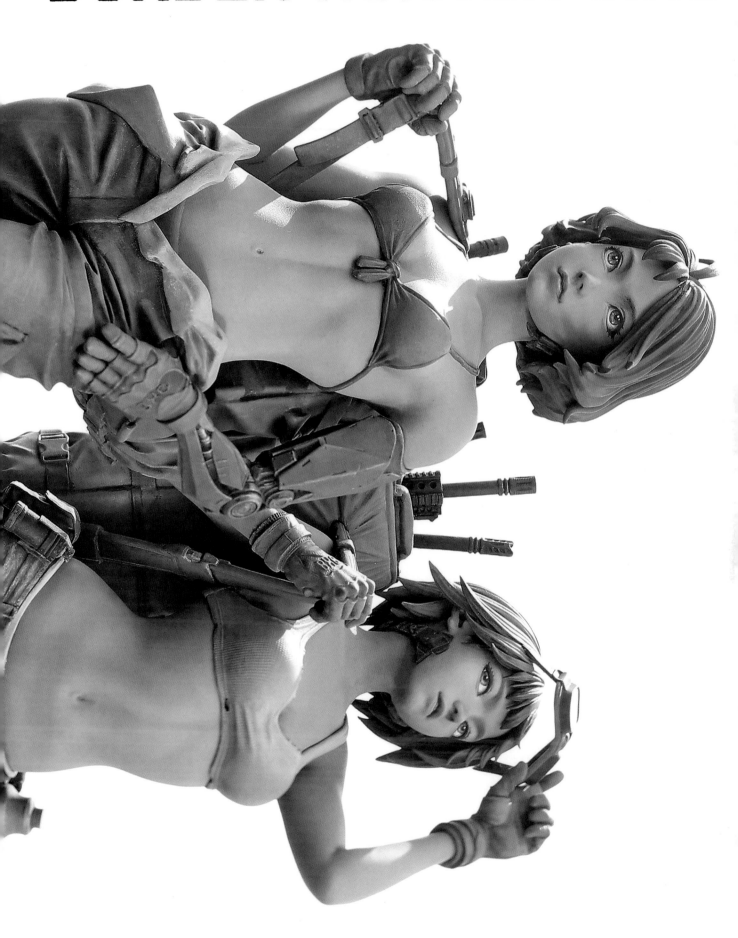

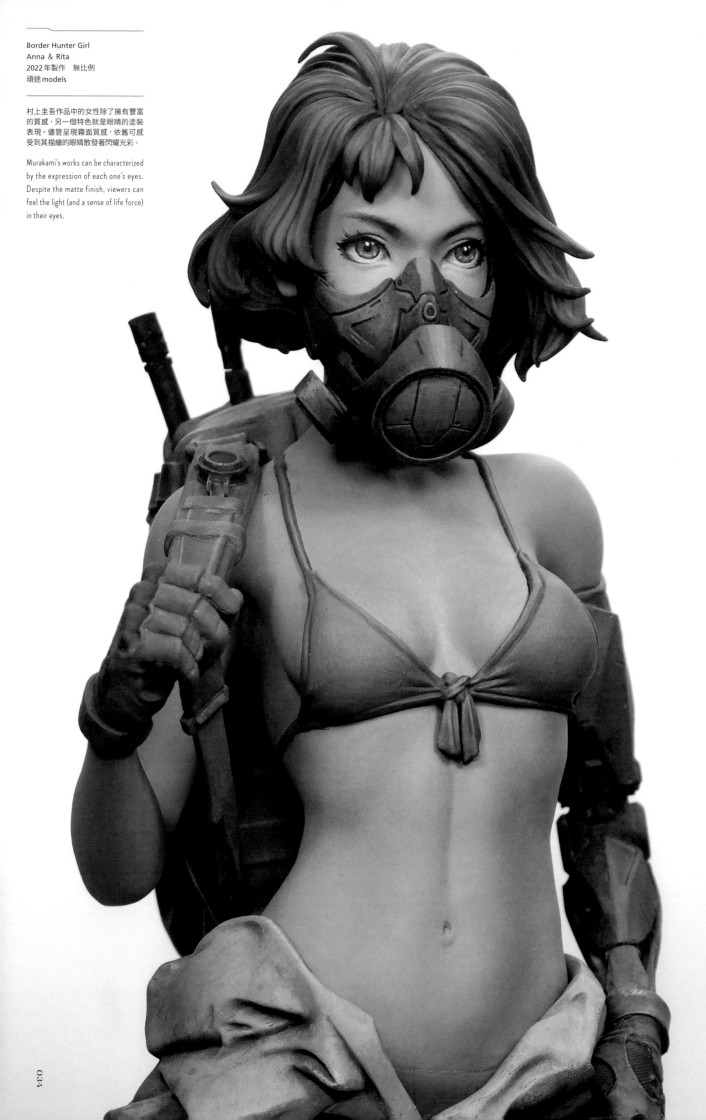

Border Hunter Girl
Anna & Rita
2022 年製作　無比例
頑途 models

村上圭吾作品中的女性除了擁有豐富的質感，另一個特色就是眼睛的塗裝表現。儘管呈現霧面質感，依舊可感受到其描繪的眼睛散發著閃耀光彩。

Murakami's works can be characterized by the expression of each one's eyes. Despite the matte finish, viewers can feel the light (and a sense of life force) in their eyes.

村上流的「可愛」甚至穿透面罩散發出來

村上圭吾作品中最多的莫過於女性人物模型。不論哪一個女性人物模型塗裝都非常可愛，總是吸引大家的眼光。
儘管如此，每個女性人物模型的塗裝都是獨一無二的存在。這次塗裝的兩個人物模型也是如此。究竟村上圭吾作品散發可愛的秘密藏在何處？

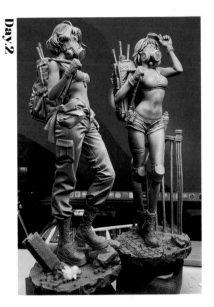

Day1

所有零件修整後暫時組裝。雖然是大型套件，但是零件的接合度佳。若是小型套件，會將整體接合後才開始塗裝，但因為這是大型人物模型，所以考慮作業的順利，並未黏接固定。另外，也會將面罩或手等部分零件拆除。

Day2

用底漆補土為整體打底塗裝。一開始先用黑色底漆補土為整體塗裝後，留意光源，再重疊塗上灰色底漆補土。

Day1

All parts were prepped and pre-assembled to check the overall condition of the figure. Despite its large size, the fit of each component was surprisingly well. Murakami typically assembles the entire kit before painting. However, for this one, he decided to leave some segments, such as the gas mask and hands, separate.

Day2

The entire surface is primed with a black surfacer, followed by a lighter, grey surfacer sprayed from the direction of the light source.

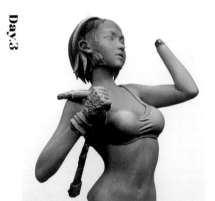

▲ 從臉部和膚色部分開始塗裝。在SCALE75（以下簡稱SC）的粉膚色中添加少量的淺膚色和焦褐色，描繪肌膚並且調整色調表現。由於面積較大，所以用比較大的畫筆塗裝，這裡只需注意顏色的濃度。

Painting begins from her skin parts using Scale 75's (SC) Pink flesh with a small amount of Light flesh and Burnt skin to adjust the tone. Base painting of the skin color was done using a large brush.

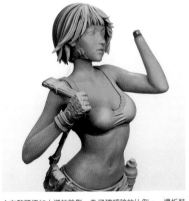

▲ 在整體添加大概的陰影。為了確認臉的比例，一邊拆裝瀏海等部件，一邊持續作業。大概在這個階段開始，將畫筆改為面相筆。

Roughly shade the entire skin surface. In order to check the balance of the face, hair parts are attached temporarily during these steps. From now on, a smaller, more delicate painting brush is used for detail work.

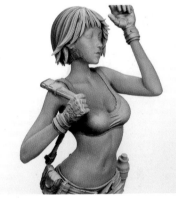

▲ 漸漸確立了肌膚大概的陰影描繪。從作業開始到這個階段大約花了1個小時。

About an hour has passed since the beginning of the painting, and overall image of her skin and shadows has been roughly determined.

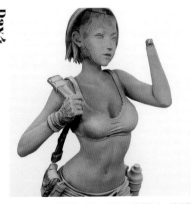

▲ 開始進入打亮作業。添加一點點SC的藝術白，並且描繪出大概的打亮塗裝。另外，這個時候也要為眼白打底塗裝。

Highlights of the skin are painted using SC's Art white, gradually mixed into the original skin color. The whites of her eyes are roughly filled in at the same time.

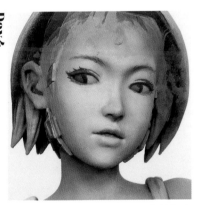

▲ 不僅僅是女性人物模型，臉部對所有人物模型來說，都是非常重要的部分。也希望大家要仔細處理視線部分的作業。這裡因為已經勾勒出大概的視線輪廓，所以描繪出黑眼珠大概的樣子。

No doubt, the face is one of the essential segments of a figure in all genres. Her line of sight is roughly finalized, and the blacks of the eyes are drawn in.

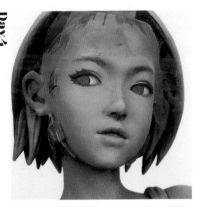

▲ 虹膜的底色為茶色，使用SC的藝術黑和焦褐色的混色。一邊對照整體的氛圍，一邊多次反覆確認調整，完成視線的塗裝。

The underlying brown of the iris was painted with a mixture of SC's Art black and Burnt skin. Her line of sight is finalized after checking the balance between the overall atmosphere of the figure.

Day.4

▲由於已確立視線，接著進入眼珠塗裝作業。描繪出虹膜和瞳孔。黃色以濃彩黃為基礎，並且以NMM技法挑選顏色後塗裝上色。

Now that her line of sight has been fixated, the next step is to paint the pupils and irises. The color yellow is based on SC's Intense yellow and drawn on as if painting with the non-metallic metal technique.

Day.4

▲同時描繪出眼睛周圍的細節。睫毛也會大大影響眼睛的表現，所以一邊大概描繪，一邊觀察上色。肌膚也是從在意的部分開始描繪並且修正。

Other elements around the eyes, such as her eyebrows and eyelashes, are further refined. These are crucial elements that significantly affect the final looks of her facial expression.

Day.4

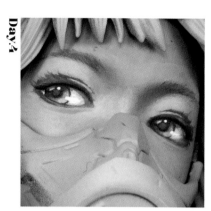

▲在虹膜上部添加藍色調，描繪出天空倒映的樣子。另外用紅色調描繪眼睛的眼神光，希望呈現出令人印象深刻的眼睛塗裝。當然這並非一定的規則理論。

Blue hues are added to the upper part of the irises to simulate the reflections of the clear sky. In addition, the color red is used as catchlight for the eyes to achieve an impressionist finish.

Day.4

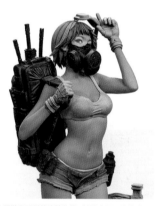

▲進入服裝和頭髮的塗裝作業。這邊也是一邊描繪出大概的樣子，一邊確立輪廓。備品在這個時候重新塗成黑色的底色。

Painting of her hair and clothing begins by roughly applying the base colors. Her equipment receives another base coat using black paint.

Day.5

▲繼續描繪頭髮，並且畫出不同裝備用品的顏色。所有部分都是一起描繪出大概的樣子，並且慢慢完成塗裝。

While fine-tuning her hair, the backpack, the water kettle, and other equipment are painted simultaneously.

Day.6

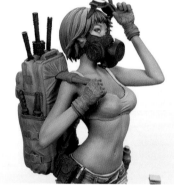

▲確認整體的比例協調，持續描繪頭髮、服裝和裝備用品。接著在各部位添加打亮。

While carefully monitoring the figure's overall balance, each segment's painting continues by adding highlights.

Day.7

▲接著同時在整體重疊上色。在SC的藝術白添加膚色，重現背心部分隱約透出裡面的樣子。其塗裝手法不同於常見的透視感表現。

To replicate the transparency of her tank-top, SC's flesh tone is mixed with Art white. This is different from the transparent effect that other figure painters typically use.

Day.7

▲進入人物模型的地面部分和靴子的塗裝。幾乎都是用乾刷和漬洗完成塗裝。描繪步驟意外地簡單輕鬆。

The boots and the base of the figure are also painted. Surprisingly, most paintwork in these areas was done using only the dry brushing and washing techniques.

Day.8

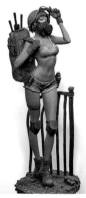

▲用相機拍照、確認照片，並且反覆之前的作業，不斷修改調整。整體完成至90%左右後結束，並且繼續描繪另一個人物模型的塗裝。

While taking pictures with a DSLR camera and checking the images, painting steps up to this point were repeated to flush out the errors and inconsistency. After finishing about 90% of the work, painting of the other figure began.

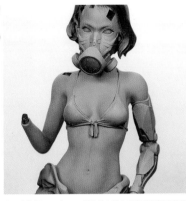

▲一次塗好Rita（Day1照片的右邊）的肌膚和眼白的底色。

This is a photo of Rita (the other figure) after finishing the basic painting of her skin tones and the whites of the eyes.

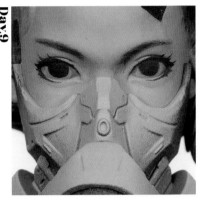

▲這是村上圭吾很喜歡的眼睛造型，可以一次將大概的視線和睫毛描繪出理想的樣子。另一方面，這是第2個娃娃，自己可以盡情持續塗裝描繪。

There are several ways of sculpting the eyes of a figure. This one is Murakami's favorite. Since Rita was painted after the first figure, he could paint her in high spirits.

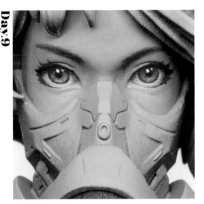

▲接著描繪眼睛的細節。這裡也是一邊描繪眼睛，一邊在肌膚不滿意的筆觸上重疊塗色。

Further detailed painting of the eyes continues, all the while refining the facial skin paint at the same time.

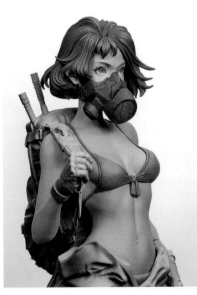
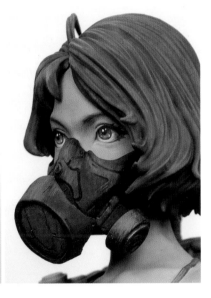

◀持續描繪肌膚的塗裝，並且開始進入頭髮和衣服（比基尼泳裝）的描繪。同時描繪肌膚、眼睛的細節，持續作業。這時也描繪出面罩大概的樣子。

While making further progress on her skin and eyes, painting of her hair and the bikini begins. The gas mask also receives a rough base color as a starter.

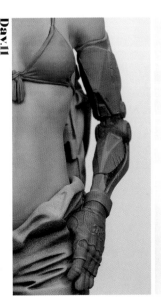
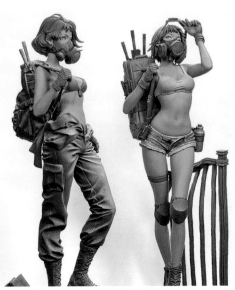

◀機械部分若考慮到實用性，一般不會使用華麗的顏色，而是用簡單、強調機能的顏色完成塗裝。畢竟是盔甲，所以只添加掉漆技法的塗裝，僅內部可見的部分描繪出亮澤的塗裝色調。這時也要一邊留意和內部的協調，一邊塗色。

It only makes sense if these figure's mechanical elements, which should prioritize functionality over flashness, were painted in a subdued uncolorful manner. Paint chippings were drawn in, and the glistening of metal was added to the inner section of her mechanical arm. This is also when Murakami starts balancing the overall finishes of the two figures.

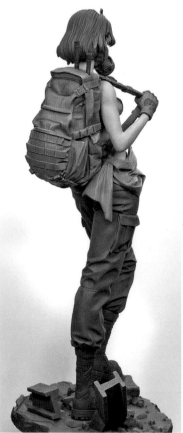

Day.12

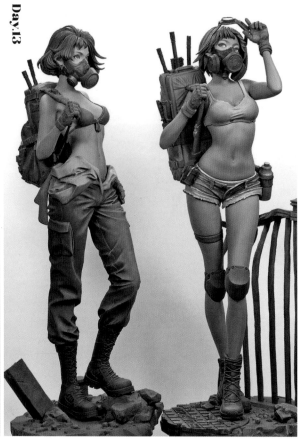

Day.13

◀接著完成整體和靴子的塗裝。
由於一開始選對了打底塗裝的底
漆補土，所以後續用染色的方式
塗上淡淡地塗料，再加上乾刷描
繪。
接著進入地面的塗裝。將2個人
物模型並排，一邊對照兩者的色
調比例，一邊持續描繪。

The overall and the boots are painted
by staining the base primer color with
thinly diluted paint, followed by a dry
brushing session.
The figure's base was also painted,
with the two pairs lined up side by side
to check their balance.

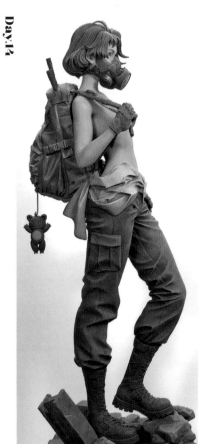

Day.14

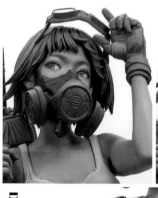

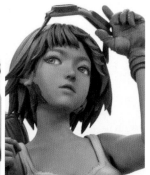

Day.15

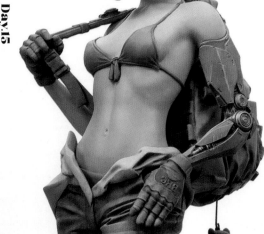

◀護目鏡受到光線照射的部分，
大膽直接使用SC的藝術白上色。因為從照片確認也不覺得不
自然，所以不再調整。另外，為
了在護目鏡和防毒面罩等部分表
現舊化感，如漬洗般塗上極度稀
釋的砂色。上色時讓邊緣和紋路
堆積淡淡的塗料，並且放置乾燥
後，塗料就會呈現如砂塵堆積般
的樣子。

The reflective glass surface of the
goggles was painted with SC's Art
white. Typically one should avoid using
pure white, but on this occasion, the
simple white tone worked very well
to replicate the light reflection. The
rest of the goggles and the gas mask
received a light wash of sandy colors.
The wash was applied to each detail's
edges, creating a realistic dust-like
residue after drying.

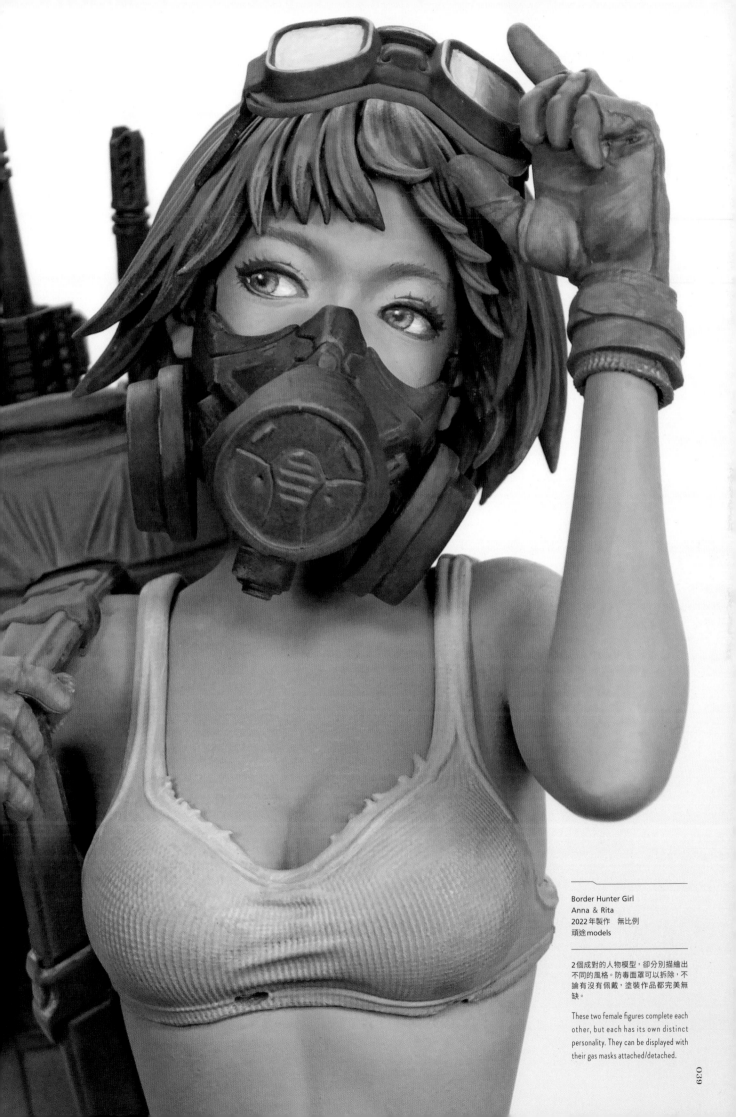

Border Hunter Girl
Anna & Rita
2022 年製作 無比例
頑途 models

2個成對的人物模型，卻分別描繪出不同的風格。防毒面罩可以拆除，不論有沒有佩戴，塗裝作品都完美無缺。

These two female figures complete each other, but each has its own distinct personality. They can be displayed with their gas masks attached/detached.

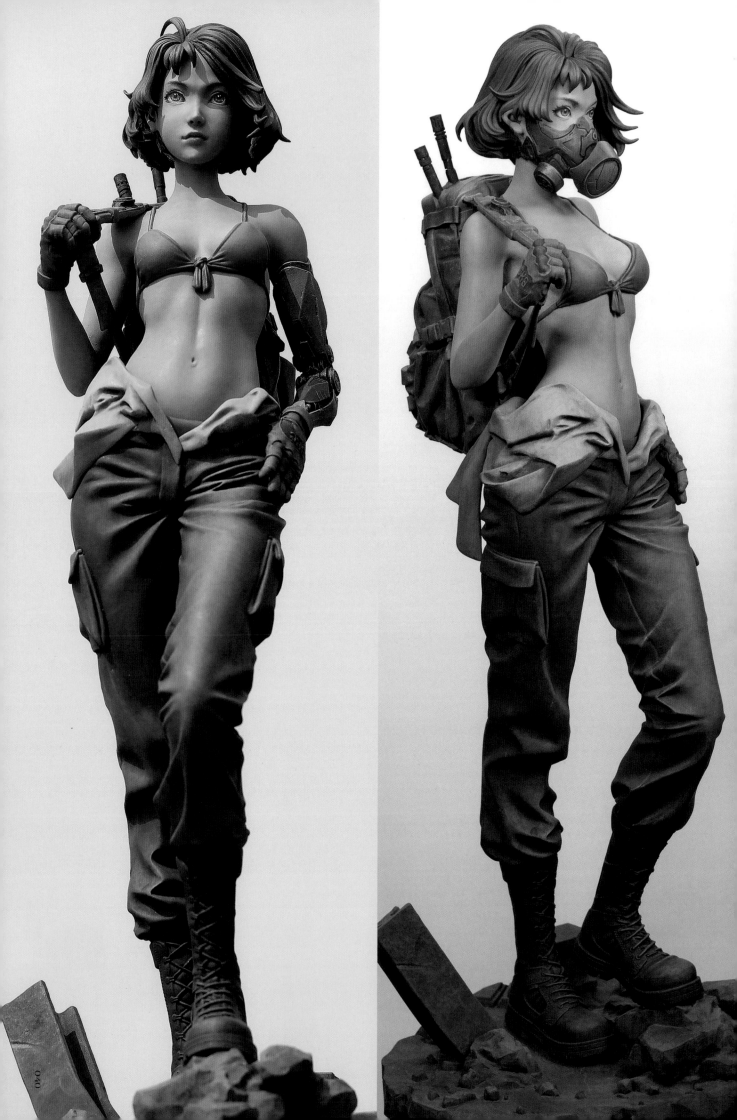

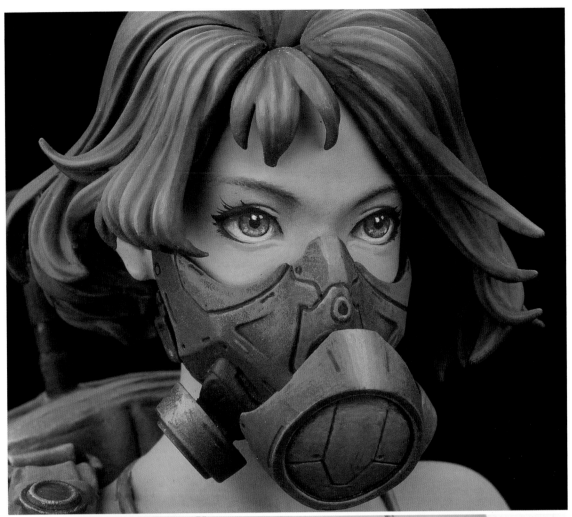

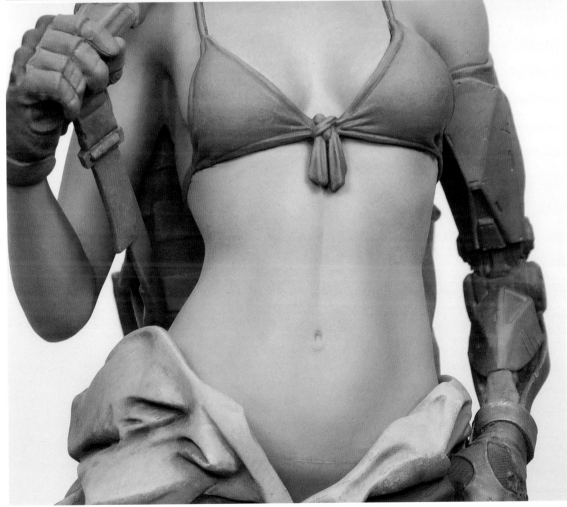

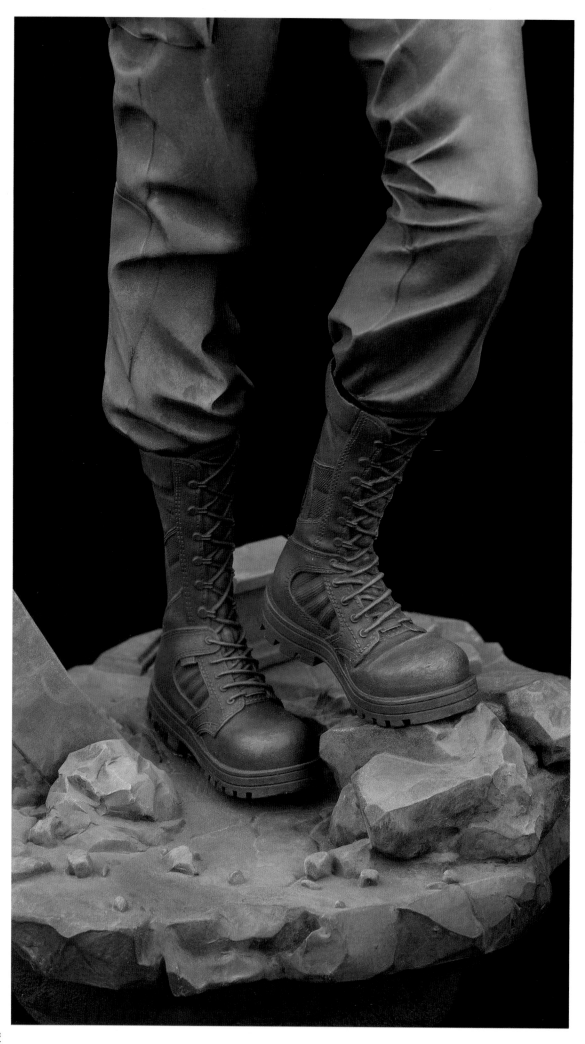

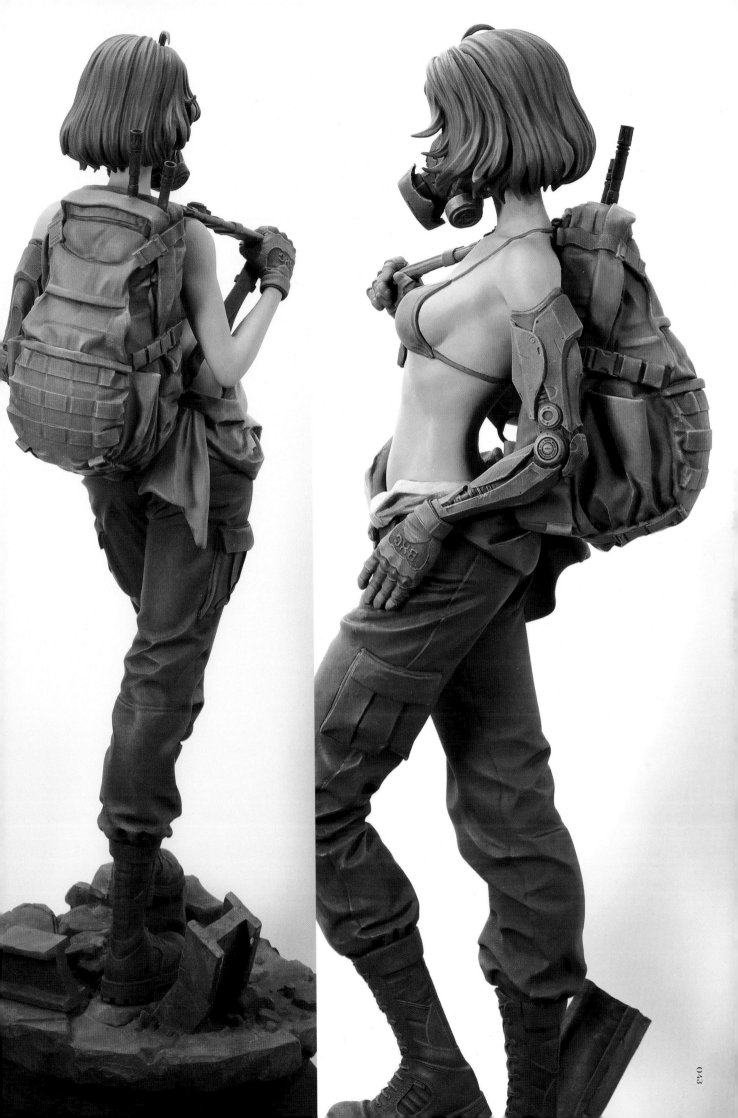

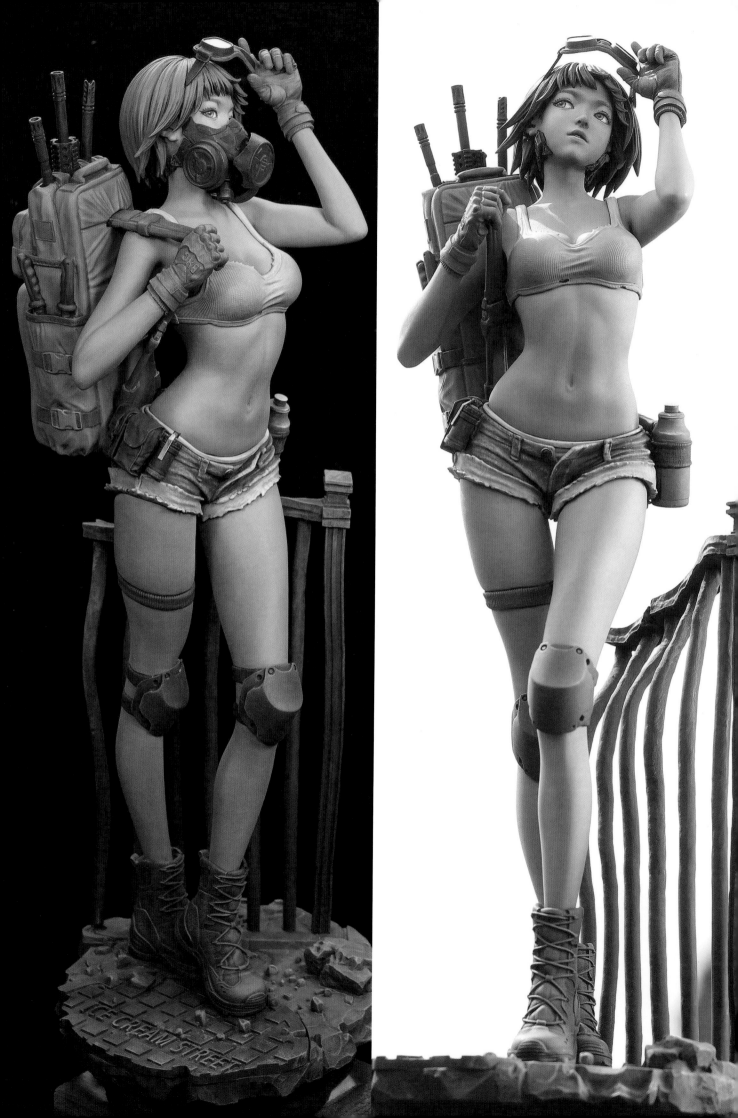

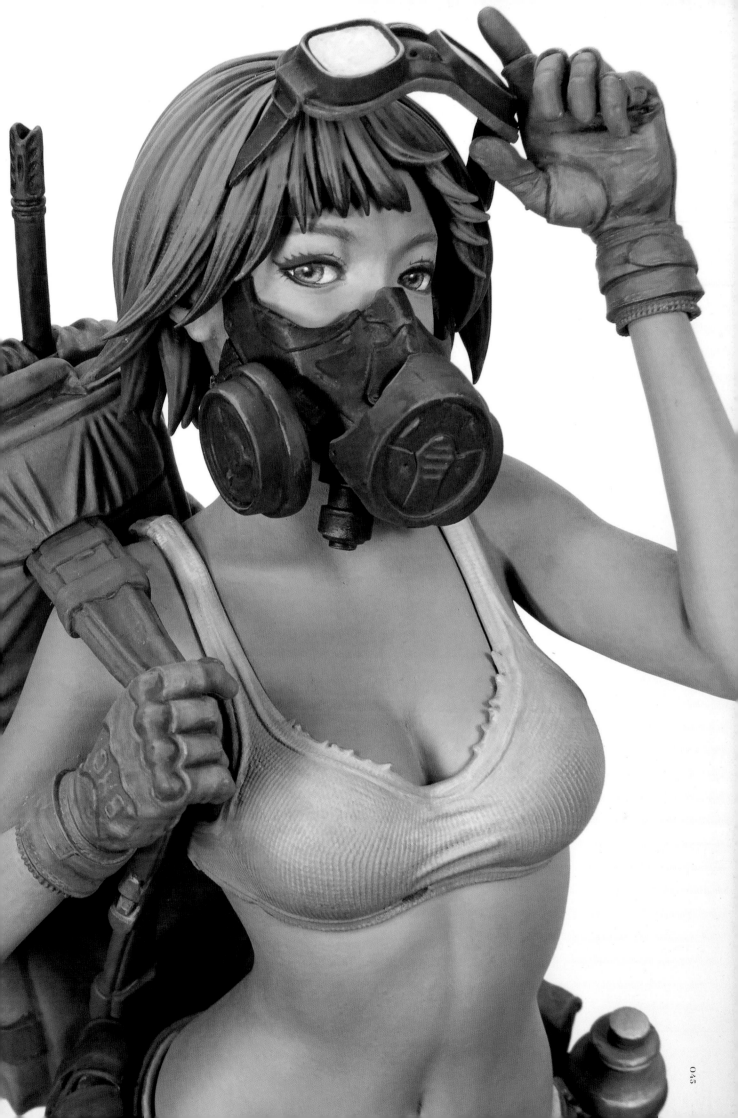

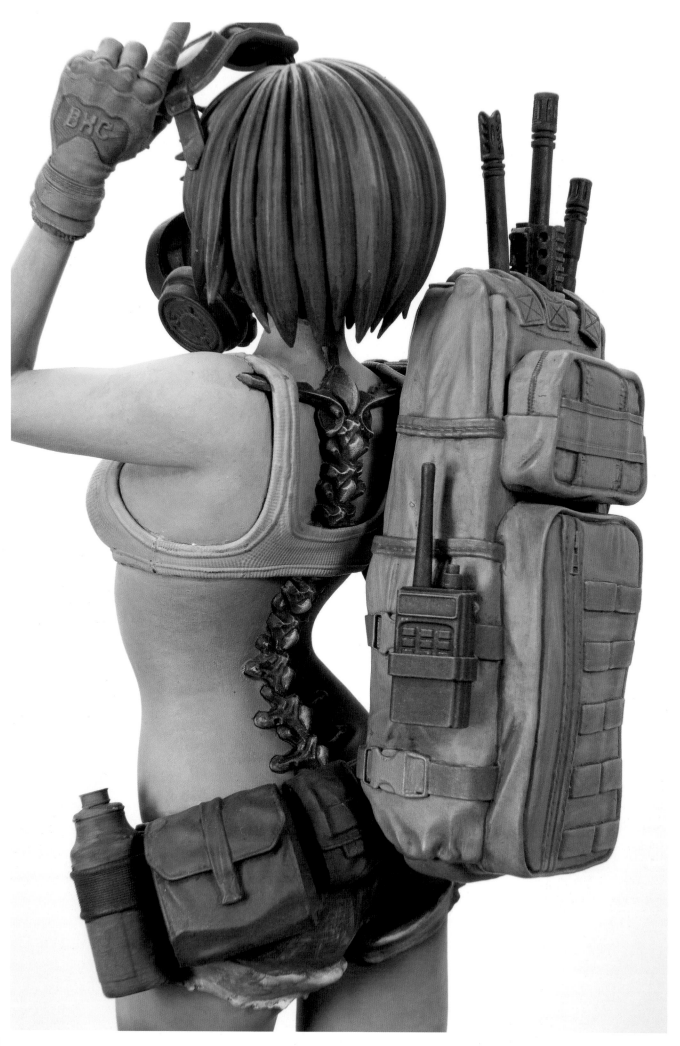

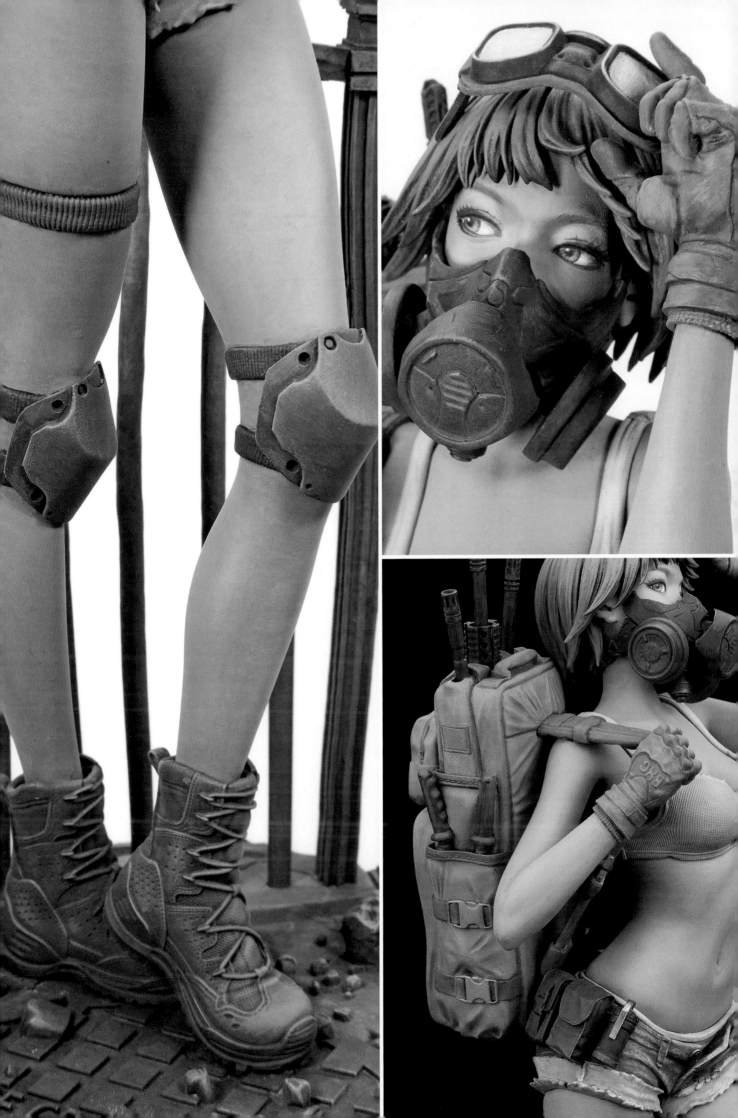

村上圭吾愛用的水性塗料精選

村上圭吾表示自己使用的塗料，其實並沒有只限定在水性塗料。一開始製作模型時也曾使用過硝基漆等塗料，但是因為水性塗料添加水就能使用，相當方便而開始改用。另外，也曾經利用油畫顏料製作過幾件作品，為了呈現出理想的作品樣貌，自己並不排斥使用其他的塗裝用品。在塗裝的過程中也不時自我詢問：「這樣的作品使用油畫顏料會不會比較容易呈現」，但似乎已習慣使用水性塗料為作品塗裝。他表示今後也想多多嘗試噴筆塗裝。看來村上流的人物模型塗裝依舊持續進化中。

Keigo Murakami says that there is actually no reason to persist in using only water-based paints. He prefers using them due to their ease of handling (and water solubility), but several of his works are also painted with oil paints. Murakami wishes to expand the use of airbrushes in the future as well. His painting style will continue evolving for the foreseeable future.

›› SCALE 75

SCALE 75 的水性壓克力顏料是他主要使用的塗裝用品。該品牌有推出許多瓶裝塗料，但是他個人偏愛使用管狀包裝的塗料。塗料最大的特色是乾燥後，塗裝表面會呈現完全消光的質感。使用上沒有特別困難之處，但美中不足的是有點難購得。

Water-based acrylic paints by Scale 75 are Murakami's main choice of paint. They come in bottled and tubed forms, but Murakami prefers to use the latter. The most significant feature of these paints is their matte finish after drying.

›› KIMERA COLOR

KIMERA COLOR 的瓶裝水性壓克力塗料來自義大利微縮模型廠商。以非常高濃度的單一顏料調配而成（30～50%），特色是即便混色也不容易顯髒。由於塗料的濃度過高，難以稀釋後使用噴筆塗裝，不過是最適合用於筆塗的塗料。

KIMERA color is a water-based acrylic from Italian miniature manufacturer, KIMERA models. These paints have high pigment density (30 to 50 percent) and purity, which contributes to retaining vividness even when mixed with multiple colors.

›› 502 Abteilung

502 Abteilung 是裝甲戰車模型師都非常熟知的模型油畫顏料，而 Dense Acrylic Colors 正是其最新開發的高密度壓克力顏料，和 SCALE 75 一樣會使作品呈現霧面質感。產品系列豐富，而且以模型師更容易理解的塗料名稱推出許多顏色。

These are acrylic paints created by a well-known oil paint brand amongst AFV models. Similar to Scale 75 acrylics, 502 Abteilung also produces a clean matte finish after drying. These are available in a wide range of colors.

村上圭吾的技巧彙整

Q1 是否有任何關於**運筆的技巧**？

Do you have any tips regarding brush strokes?

A1

避免描繪出交界或**刻意留下筆觸時**，會稍微改變線條的粗細。另外，意外地常使用乾刷技巧。

I alter the thickness of the line slightly depending on the effects I'm after. Sometimes I even intentionally leave stroke lines. I'm also a big fan of the dry brushing technique

Q2 使用**管狀**水性顏料最主要的原因是？

Why do you prefer to use tubed water-based paints?

A2

水性塗料**很快就會乾燥**。還有瓶裝塗料要花一點時間搖勻瓶中塗料。每次的攪拌作業都讓我感到厭世不已。加上我擔心瓶裝塗料會呈現出非我預期的光澤，但是管狀塗料**已完全去除光澤，這點深得我心**。

Water-based paints have a quicker drying time. I also don't like how the bottled ones require intensive shaking before using them. They also tend to have uneven shine, but the tubed ones always leave a perfect matter finish after drying.

Q3 是否有作品是使用**其他繪畫用品**完成塗裝？

Have you ever used paints other than water-based ones?

A3

在 Klondike's 的人物模型（右上角）塗裝中，連衣帽和靴子的質感是利用油畫顏料塗裝。其他還有幾件作品是用**油畫顏料塗裝完成**。

For Klondike's sculpture, I used oil paints to paint skin texture. There are several other works of mine finished using oil paints.

Q4 為了完成塗裝作品，是如何構思**發想**？

How do you get your inspiration when painting these sculptures?

A4

前期並非模仿其他模型作品，而是喜歡將作品完成如**插畫或繪圖**的感覺，並且樂在其中。因此我是從**人物模型以外的資訊**汲取靈感。動漫、插畫或電影等，每次都不盡相同。

I like to paint figures just like an artist would paint their artwork. Rather than imitating other figures/sculptures, I get my inspiration from different genres, such as animation, illustrations, movies, etcetera.

Q5 最**喜歡**做哪一個部分？

What makes you the happiest as a painter?

A5

將作品在展示會展示、塗裝交流會、塗裝直播我都很喜歡，但最喜歡的還是塗裝作業的當下。**即使現在我**內心還是**期望能更加提升自己的塗裝作業**。

I love everything about painting figures. Attending events and hosting live painting sessions, but I must say my favorite time as a painter is… when painting figures. Even now, I am filled with the desire to become better as a painter.

Q6 **快速**完成塗裝所需的秘訣是甚麼？

What's the secret to painting figures so quickly?

A6

事前就需要先設定好將作品塗裝至某一個程度的**期限**，先訂下初步的時程表。因為若沒有限定時間作業，有時甚至會悠哉地花一個月以上的時間。

I typically set a deadline in advance and make a rough schedule according to that date. Without this, I'll easily spend more than a month painting a single sculpture.

Q7 關於塗料稀釋有特別**講究**的地方嗎？

Do you have a particular preference when diluting paints?

A7

實際為作品塗裝時，會使用到塗料的各種濃度。有時不稀釋而是直接塗上顏料，有時又會使用比漬洗還低的稀釋度上色。使用習慣大概是越接近完成階段濃度越低。很多人都會問我這個問題，但是我無法明確說出稀釋的比例，只能以我個人經驗說明大致的使用方式。不過雖然我是在塗裝的步驟過程中稀釋，但是我卻**很注重當下稀釋的濃度調整**。

I have a rough idea of how much to dilute each paint based on my experience, but it's hard to describe that in words. Though, that doesn't mean I'm diluting paints in a roundabout way. I do take extra care with the thickness of paints according to each situation.

Q8 是否有喜歡的國外塗裝師？

Are there any international figure painters that you are interested in?

A8

putty and paint 是一個集結人物模型塗裝師的 SNS 平台，我會留意在這上傳作品的塗裝師。其中我喜歡 Marc Masclans、Arnau Lazaro、Patricia Sancho、John Chan 的作品。但是只是激發自己的靈感，我並不會當成範本塗裝。我想用其他的手法完成塗裝。因為即便我模仿這些作品，也無法超越這些原創，而只會淪為粗糙的複製品。

I'm a big fan of the figure painter community website "Putty and Paint." I especially love the works by Marc Masclans, Arnau Lazaro, Patricia Sancho, and John Chan. They inspire me a lot, but that doesn't mean I imitate their style. I want to be different and unique. Copying their style will only create a lesser quality knock-off.

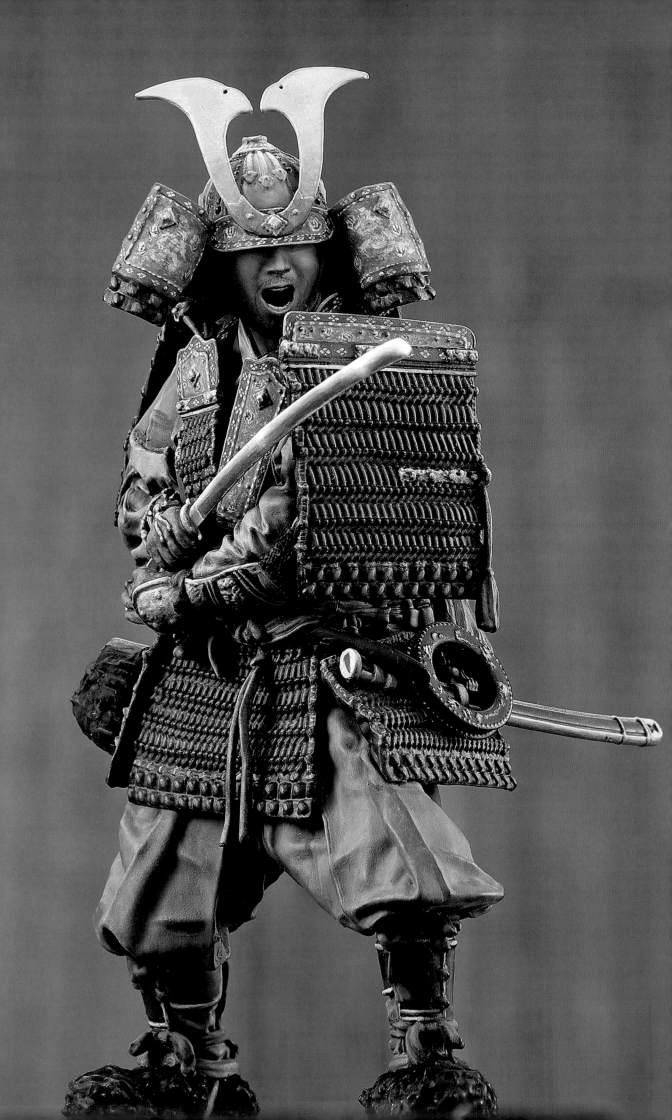

鎌倉時代の鎧武者

樸質剛健的鎌倉武士魂在令和時代甦醒

1/12 比例的鎌倉時代盔甲武士雖然是塑膠射出成型的套件，卻有令人讚嘆不已的還原度。即便簡單塗裝，細節豐富的套件也會顯得栩栩如生，村上圭吾在這件作品充分展現了村上流的塗裝風格。作品表現出盔甲色彩豐富的塗裝、武士活靈活現的表情，還有水性塗料可呈現的深度。

▲仔細處理湯口後暫時組裝。整體塗上黑色底漆補土，從光源方向添加灰色底漆補土後，確認整體氛圍。

Carefully cut and sand off each part's attachment points and temporarily assemble the figure. Apply a black surfacer, followed by a grey primer sprayed from the direction of the light source.

▲這次也是從臉部開始塗裝。造型非常精良，尤其嘴巴的部分，一上色就呈現出塑膠模型少見的質感。

Painting starts from the warrior's face. Despite being an injection-molded plastic kit (Murakami typically works with resin-cast kits), this figure has surprisingly crisp detail, especially around its mouth.

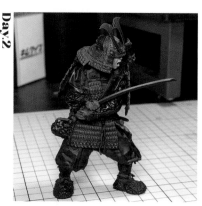

▲身體先塗滿SCALE 75（以下簡稱SC）的藝術黑後，正式進入塗裝。紅色部分使用502 Abteilung（以下簡稱AB）的紅黑色，大概塗上即可。

The figure's body was first painted with Scale 75's (SC) Art black. 502 Abteilung's (AB) Reddish black was then roughly applied to the red areas of the warrior's armor.

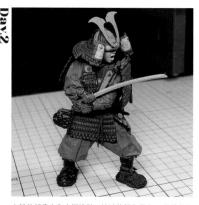

▲其他部分也先大概塗裝。袴褲的顏色是在SC的薄荷綠和苔蘚綠的混色中，添加濃彩黃和焦褐色，塗裝時要隨時調整色調。

Other segments also received basic colors. The brownish green of the warrior's hakama (undergarment) is painted with a mix of SC's Spring green and Moss green, with Intense yellow and Burnt skin added accordingly.

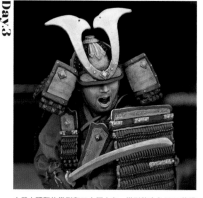

▲武士頭盔的鍬形和刀大概上色。鍬形的金色以SC的濃彩黃為基底，預計用NMM的技法完成塗裝。武士頭盔的吹返圖案也大概上色。

Painting of the kabuto (helmet) and the katana begins. The kabuto's hoe-shaped helmet crest (aka kuwagata) is painted using the non-metallic metal technique, the base color being SC's Intense yellow. The underside of the kabuto also received a rough paint job.

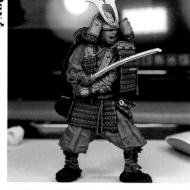

▲慢慢進入細節描繪的作業，並且增加整體的資訊量。這時還沒有描繪出武士刀的雛型。

More details are added as the painting of each segment continues. At this point, the final finishing style of the katana has not yet been determined.

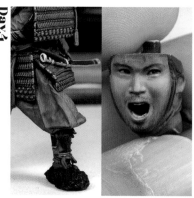

▲先試著描繪出袴褲的圖案細節。這個部分可以參考真實的資料並且持續作業。臉部和鬍子都描繪出大概的細節。

After researching historical documents, appropriate patterns were drawn on the hakama (left image). Adding a beard is an excellent way to increase the ferociousness of the warrior (right image).

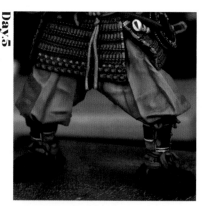

▲上色時塗至袴褲圖案若隱若現的程度。重疊塗上袴褲的顏色，讓圖案呈現若有似無的樣子。

The previously painted patterns of the hakama were faded to an almost unrecognizable level with a green overlay.

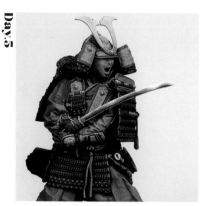

▲終於要描繪武士刀的塗裝。不要太在意武士刀實際的樣子（光源或反光等），盡量塗裝成令人深刻的樣子。

The reflections drawn on the katana may not be accurate in terms of realism, but the artistic approach was prioritized to maximize its impact on viewers.

Day.5

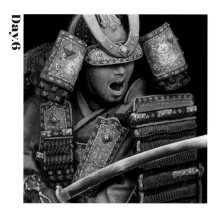

▲開始描繪眉庇和吹返等處的圖案細節。圖案非常細膩，參考實際資料作業。

The details of the kabuto's forehead (mabisashi) and side (fukikaeshi) armor plates were painted. These decorative patterns are painted with historical accuracy based on reference materials.

Day.6

▲接著描繪圖案的細節，並且在這個階段描繪出各處的縫線。

More details are painted on, such as the stitches in various armor plates.

Day.7

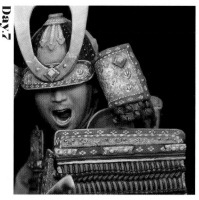

▲加強描繪圖案的細節。這裡的塗裝需要反覆而且有耐心地添加筆觸。

Painting of decorative patterns continues with utmost precision and patience.

Day.8

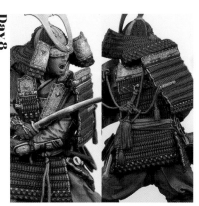

▲確認拍下的照片，注意是否有錯誤的地方。因為很在意背後紅色的顯色度，所以修改這個部分。

Errors are spotted from images taken with a DSLR camera. On this occasion, the redness of the rear section of the armor plate seemed a little off and was adjusted accordingly.

Day.9

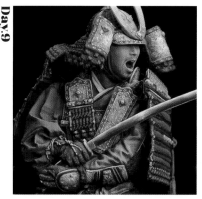

▲以布料材質為主，調整質感。另外，眉庇等圖案部分繼續描繪出細節。

More adjustments are made, focusing on the warrior's garments and their textures. The decorative patterns of the armor plates are further refined.

Day.9

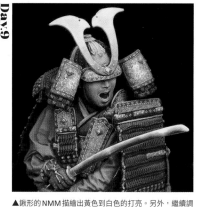

▲鍬形的NMM描繪出黃色到白色的打亮。另外，繼續調整紅色顯色不佳的部分。

As mentioned before, the helmet crest is finished using the non-metallic metal technique. The base paint of the crest is yellow, with the color white added for its highlight. A few areas of the red armor plate that lack vividness also require adjustments.

Day.9

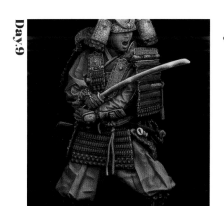

▲再次修改布料部分的打亮。到了這個階段，已經進入微調整的作業，不仔細觀看照片無法察覺，但是一定會針對在意之處多加著墨。

More adjustments are made to the highlights of the warrior's garments. At this point, it's hard to spot the difference before and after the corrections, without magnifying the images taken with a camera.

Day.10

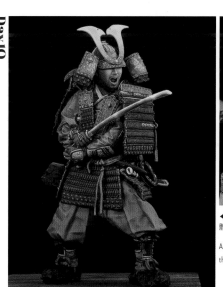

◀▲不滿意臉頰部分，所以持續調整至臉部完成。確認整體外觀和照片，再次修飾紅色的顯色度後即完成。

After applying further corrections to his cheeks and armor plates, the figure is completed.

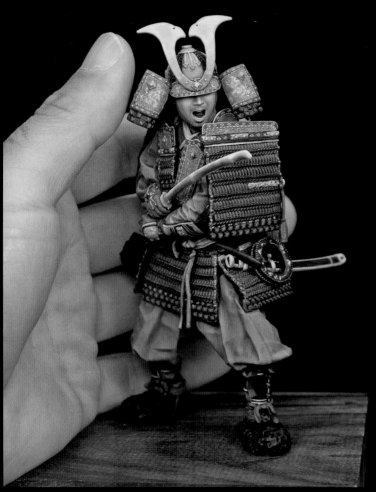

Kamakura Period Armored Warrior

3D SCAN

鎌倉時代の鎧武者

Calligraphy : UTSUGI SENKYOH
Illustration : Taro Yamazaki

PLAMAX
Max Factory

1/12 SCALE
PLASTIC MODEL KIT SET

PLAMAX 1/12 鎌倉時代的盔甲武士
（Max Factory 1/12）
預定 2022 年 8 月發售
射出成型塑膠模型
含稅 4180 日圓

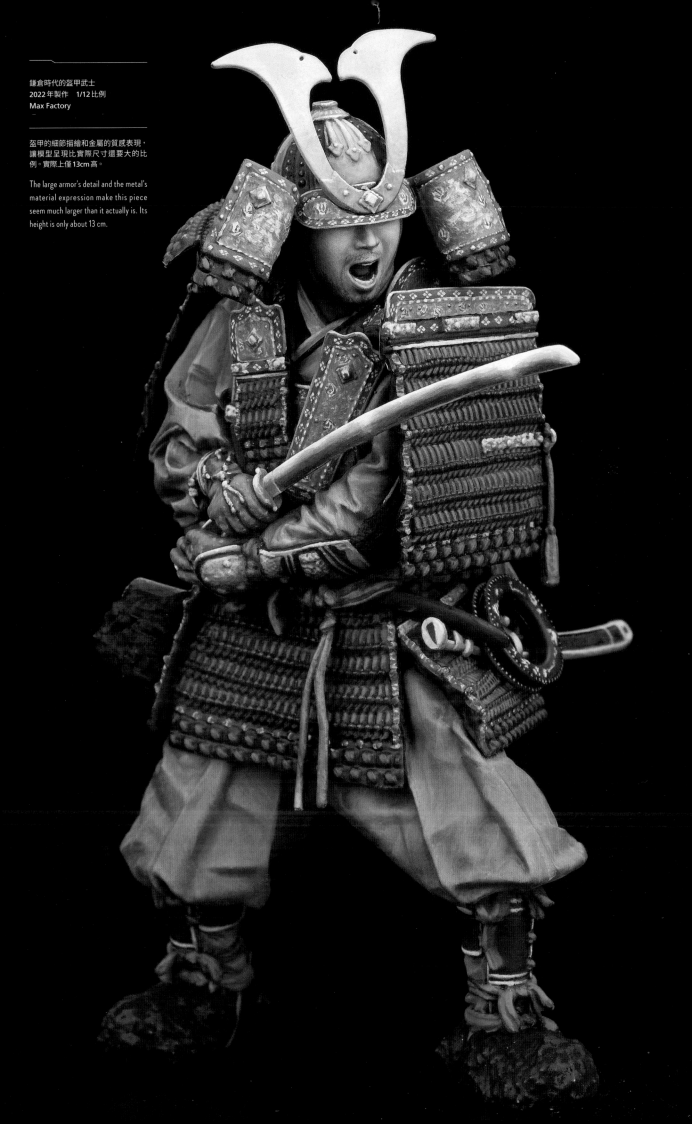

鎌倉時代的盔甲武士
2022 年製作　1/12 比例
Max Factory

盔甲的細節描繪和金屬的質感表現，
讓模型呈現比實際尺寸還要大的比
例。實際上僅 13cm 高。

The large armor's detail and the metal's
material expression make this piece
seem much larger than it actually is. Its
height is only about 13 cm.

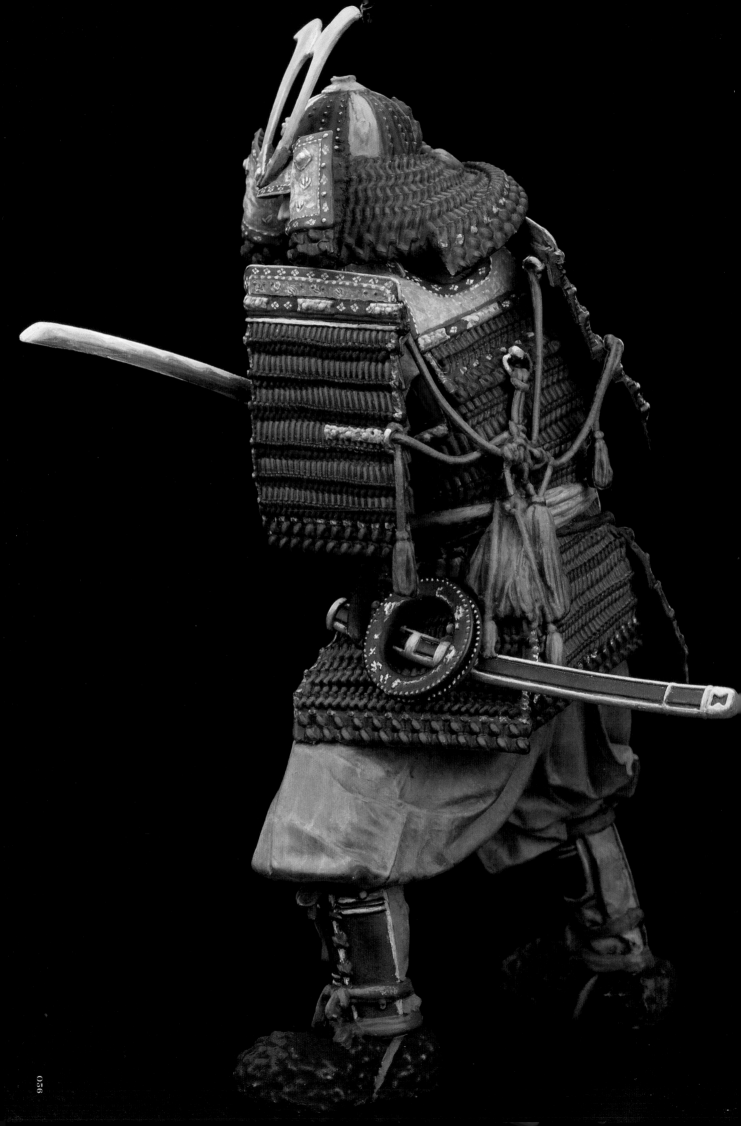

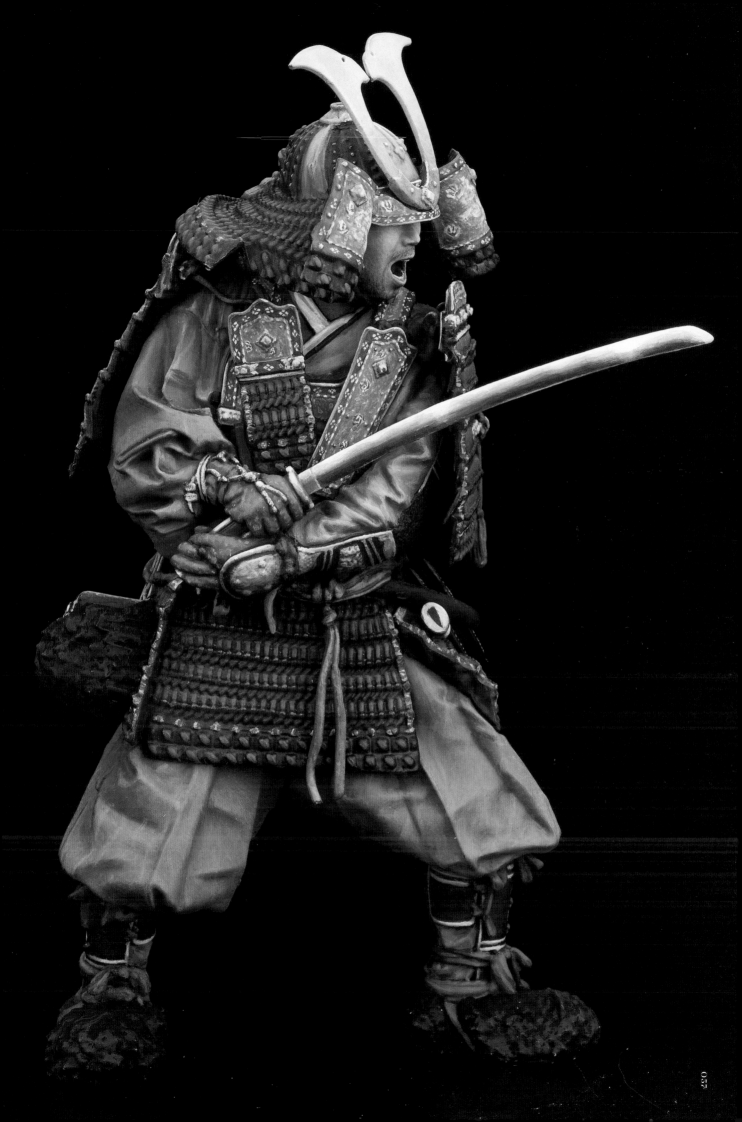

by Histone

在原型師的眼中，何謂村上圭吾稱得上「貨真價實」塗裝師的實力

村上圭吾是我目前最關注的日本塗裝師。

對我來說，高水準的塗裝師應具備以下條件。

① 各種領域的塗裝實力
② 各種套件比例的塗裝實力
③ 任何作品都表現出符合主題的塗裝實力
④ 不論哪種領域或比例的模型，作品都具有很高的辨識度，散發創作者的風格

作品橫跨不同領域和尺寸比例的模型師很少。而能在作品中呈現一貫創作風格的模型師更是少之又少。每位模型師都有各自偏好的領域或擅長的尺寸比例。但是只觀看特定領域、特定尺寸比例的作品，我們無法看出一個人內在擁有的本質或「本事」。然而讓創作者製作或塗裝不擅長的領域時，可能會顯露其內在本質擁有的原貌，另一方面也可能卸除其偽裝的表象。基於這些理由，我認為符合上述條件才能證明這個人是「貨真價實」的塗裝師。

我之所以非常欣賞村上圭吾，正是因為他完全符合這些條件。另外，從每件作品都是全新挑戰並且持續進化這點，也可以一窺他在技術方面的無盡追求與熱情。雖然我未曾向他本人請教，但是想必他曾仔細研究過各領域的塗裝師創作，並且努力將每個人的優點化成自己的風格。

我大概看過村上圭吾描繪了2件由我製作原型的人物模型。我在其中看到自己在創作時腦中想像的造型塗裝。從這一點就充分證明，他能從造型充分讀取到原型師想像的塗裝，並且擁有將其轉換成顏色的技術與表現能力。我認為他是極少數讓原型師希望，「一定要讓這個人為自己作品塗裝」的塗裝師。

Histone
歷史微縮原型師，曾在歐洲軍事模型展、IPMS和Monte San Savino Show等各國知名大賽獲獎。著作有『用美術用壓克力顏料塗裝微縮模型胸像的塗裝技法』（Kindle）。

Histone is a historical-miniature sculptor who has won many awards at prestigious worldwide competitions such as "Euro Miniature Expo," "IPMS," and "Monte San Savino Show." He is the author of "Painting Techniques for Miniature Busts with Acrylic Paints for Art," available on Kindle Amazon.

For me, Mr.Murakami is the most interesting Japanese figure-painter. The qualification for being a master painter is, in my opinion, as follows.

1. They can paint a wide varaety of subjects.
2. He/She can paint at any scale.
3. Every work of his/her has a matching style with the subject.
4. Regardless of subjects and scale, the painter is easily recognizable via their unique style embedded in their work.

Many painters can paint certain subjects, at a certain scale, spectacularly. However, it is rare to see a painter who can maintain quality no matter the subject/scale they are working on. A skillful painter can confidently paint at his maximum level regardless of what they paint. That's what I call a "true master."

I highly appreciate Mr.Murakami's works because he has fulfilled all four of the qualifications. The fact that he continues to take on new challenges and evolve with each newly finished piece shows his relentless pursuit and passion for painting techniques. Although I have not had the opportunity to ask him personally, I suspect that he has studied many different genres of painters and strives to incorporate the best aspects of each into his style.

I have seen Mr.Murakami painting two of my sculptures. It was as if Mr.Mukarami had seen inside my head, as the finishes of these figures were precisely what I had imagined while sculpting them. This is undeniable proof that he is a master painter with exceptional skills. I think from my heart that Mr.Murakami is the type of painter who makes us, the sculptors, wish that he works on our sculptures.

這是以 Histone 原型製成的軍事人物模型，個性十足，表情和姿態流露著男性魅力。

These are some of the sculptures created by Histone. Their facial expressions, postures, and the overall atmosphere is overflowing with masculinity.

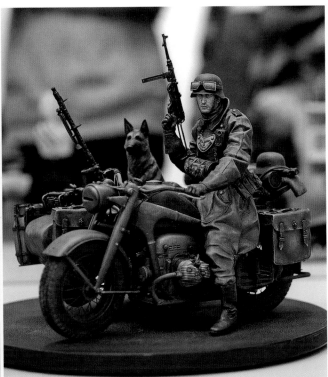

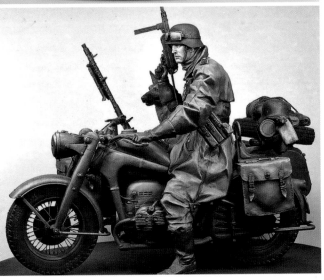

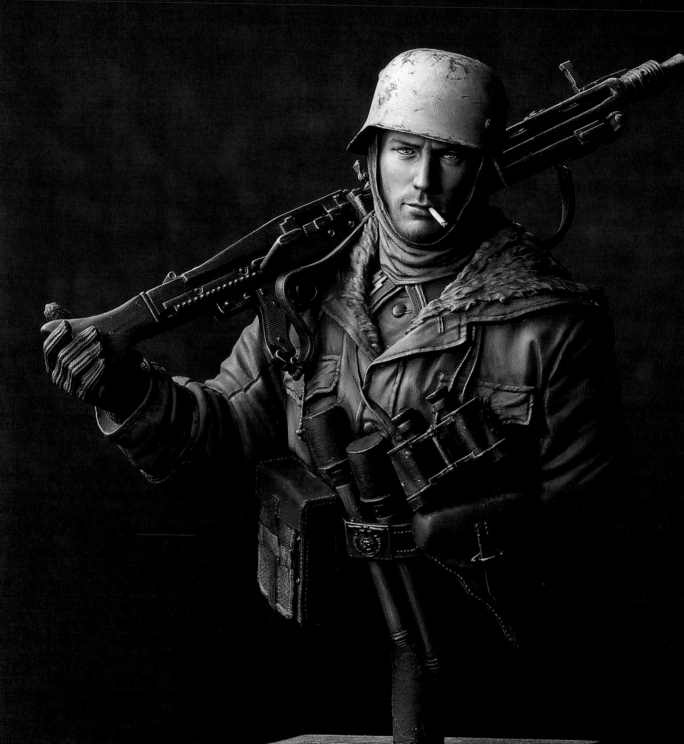

WW2 German
MG42
Gunner

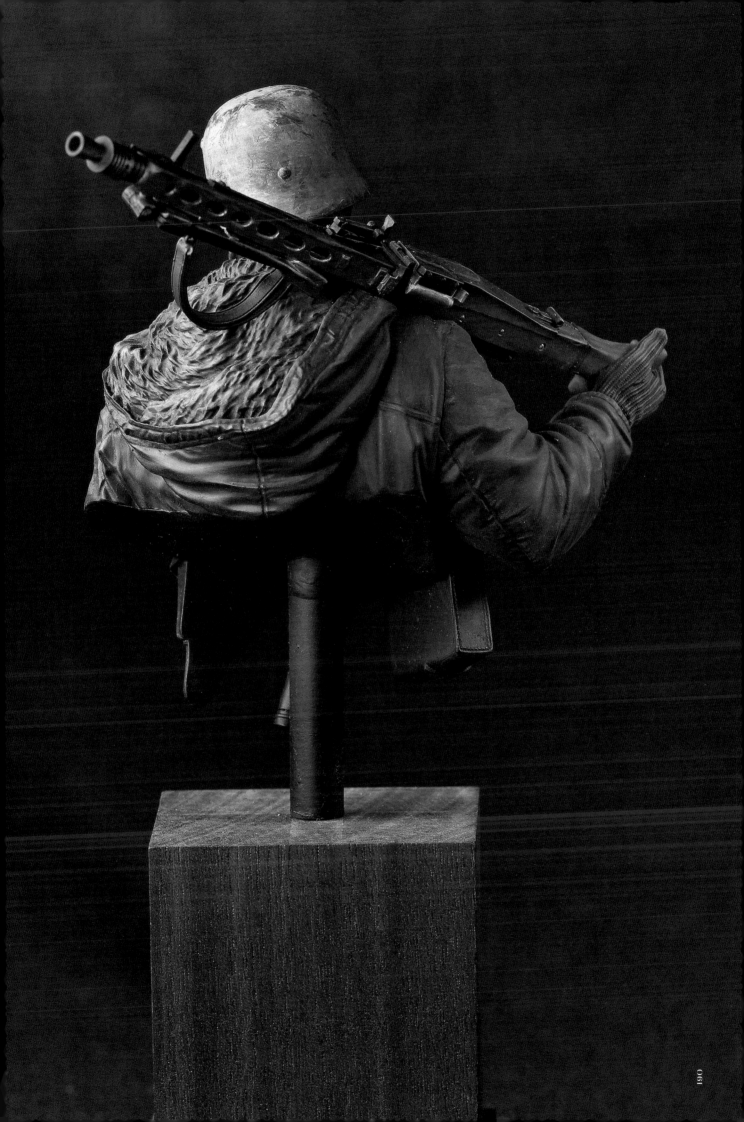

盡情展現粗曠的男性魅力

軍事類的胸像模型造型，除了臉部之外，身上的裝備和服裝每一個細節都需要呈現高水準的質感表現。村上圭吾在這次的塗裝作業中，不但充分展現出這些細節的質感，還在關鍵部位融入屬於村上流的創意表現。大家可以從村上流的軍事塗裝作品中，充分感受到男性人物模型獨特的魅力。

▲暫時組裝所有零件，並且塗上打底塗裝。先用黑色底漆補土鍍層，再留意光源方向，疊加上灰色底漆補土。

The figure was temporarily assembled and primed using a black surfacer. Next, a grey surfacer was sprayed from the direction of the light.

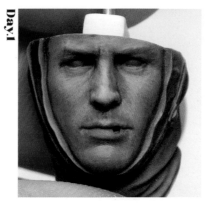

▲膚色使用SCALE 75（以下簡稱SC）粉膚色、淺膚色的混色，並且用金黃膚色或焦褐色調整色調。

The skin tone is mixed from Scale 75's (SC) Pink flesh and Light flesh, with slight adjustments made using SC's Golden flesh and Burnt skin.

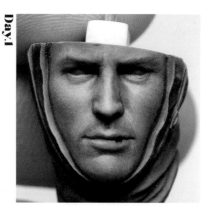

▲分別在臉頰用膚色混合SC的緋紅色上色，在陰影部分則用膚色添加綠色和SC的暗群青混色上色，增添色調的變化。

His cheeks received some warmth using SC's Crimson. Greens and Dark ultramarine were mixed into the base skin color to be applied on shadows.

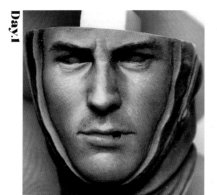

▲鬍子區塊稍微保留一點打底的底漆補土。接著持續添加打亮的描繪筆觸。在膚色添加SC的藝術白調整修飾。

The beard on his face has a rough appearance. This is achieved by intentionally leaving the painting surface un-prepped. More highlights of the skins are drawn using SC's Art white.

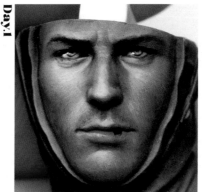

▲一邊調整藍色調和紅色調，一邊修飾肌膚。在這個階段也大概描繪出眼睛的塗裝。

The blue and red hue of the skin is adjusted accordingly until an ideal balance is achieved. At the same time, his eyes are roughly painted.

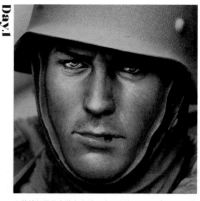

▲將臉部零件安裝在身體，確認視線，並且再次微微調整人物視線。

The face and head parts are temporarily attached to the body piece to check and adjust his sightline.

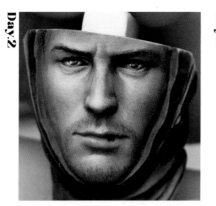

▲一邊想想某位漫畫人物角色，一邊在眉毛的周圍添加鬍子。並且在臉上再添加一點淡淡的汙漬。

Imitating a certain anime character, his eyebrows and beard receive more details with a more delicate paintbrush stroke. The face is also lightly weathered to give the pitiless feel of the battlefield.

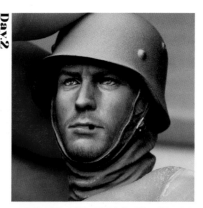

▲開始描繪連帽、頭盔以及繫帶部分。連帽以茶色和膚色的混色為基調，並且稍微添加一點調盤上已有的少許顏料。

The focus of the painting shifts to his helmet, hood, and straps. The base color of the hood is a mixture of brown and skin tone, followed by a variety of previously used colors on the palette.

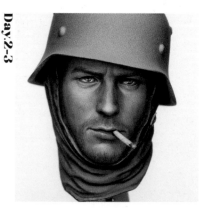

▲調整臉部和連帽的交界。描繪香菸的塗裝，這時香菸的前端描繪得太亮，所以後續會再調整修飾。

The borderline between his face and the hood is refined. Tobacco is also painted at this point. The tip seems a little too bright but was dimmed at the later stages of the painting.

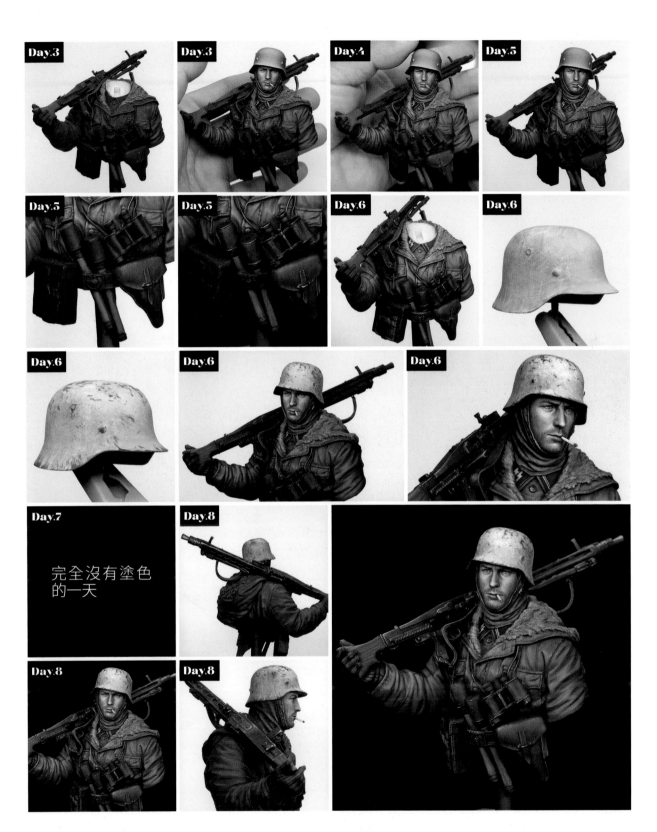

▲外套的田野灰色調混合了SC的綠松色和茶色（這裡使用了焦褐色），並且又添加了暗綠色加以調整。連同裝備先大致上色。一邊慢慢添加打亮，一邊確認質感並且持續描繪。服裝的塗裝時間大概描繪至Day5，接著進入皮革、木頭和金屬部分的描繪作業。描繪這些細節時都參考了真實的資料。另外，還添加了舊化處理，主要使用茶色添加濾鏡效果。除了放在白色背景之外，也放在黑色背景前拍照確認。

頭盔完成至大約60%後，用舊化處理調整整體的色調比例。中間間隔一天完全不作業，讓大腦放空重啟，隔天再以全新視角客觀檢視整體。不斷反覆確認調整直到最後一刻即完成。

The field grey of his jacket was painted with a mixture of SC's Turquoise blue and Burnt skin (Brown), with slight adjustment made with Sap green. At the same time, his other equipment received base colors, followed by the detail and highlight painting to enrich their textures. Most of his clothing was finished by Day 5, and paintwork on other areas such as leather straps, wood surfaces, and metals began. The majority of the weathering process was done by applying a filter wash with brownish paint. Many photos were taken with a DSLR camera (in white and black backgrounds) to check for flaws. It is essential to check the overall balance of each segment mid-way through the weathering process (Day 6). After a 24 hours break, Murakami applied several more corrections and adjustments.

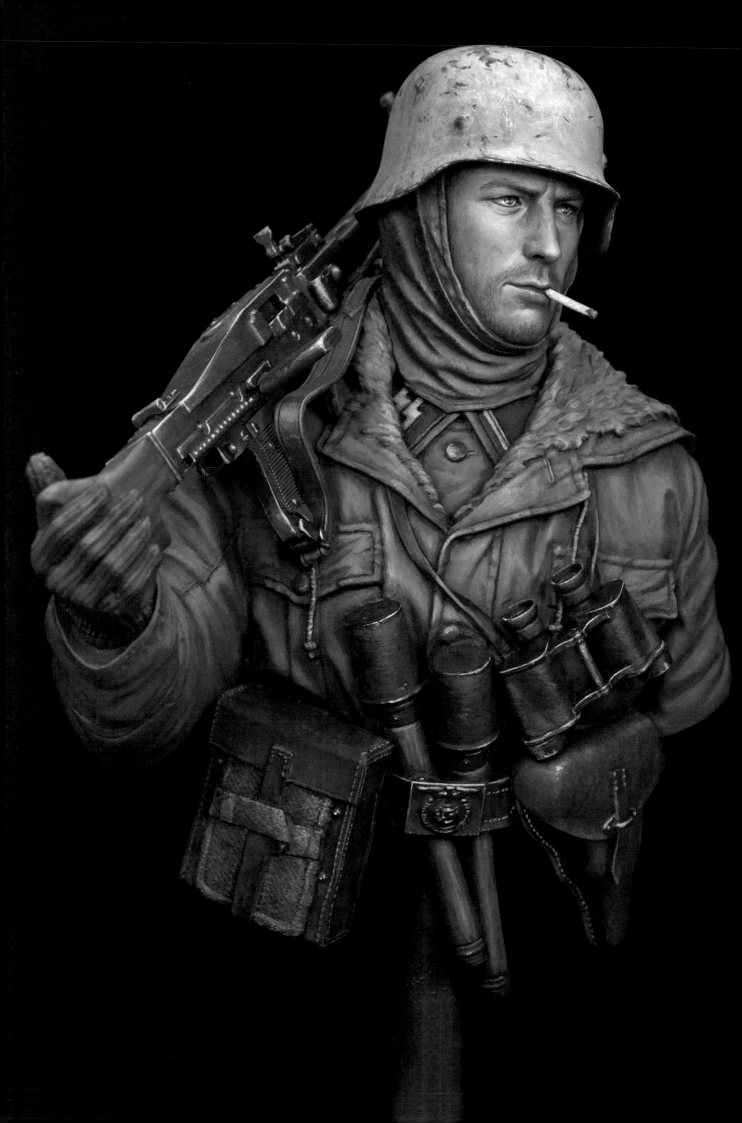

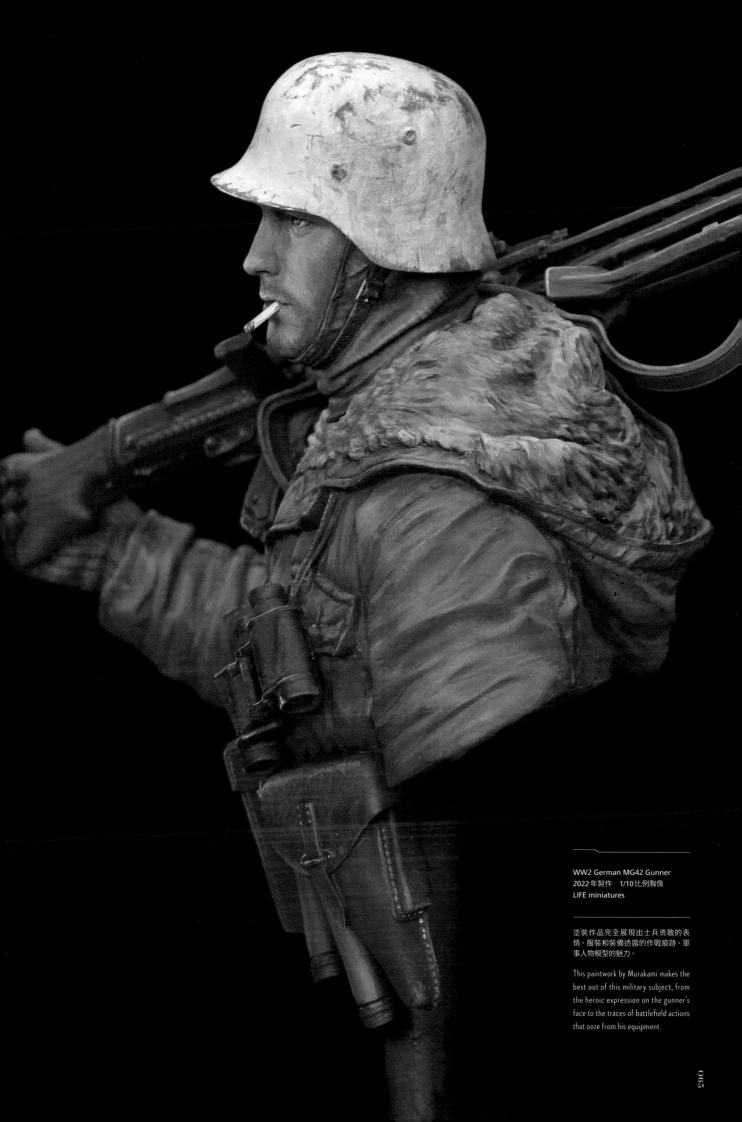

塗裝作品完全展現出士兵勇敢的表情、服裝和裝備透露的作戰痕跡、軍事人物模型的魅力。

This paintwork by Murakami makes the best out of this military subject, from the heroic expression on the gunner's face to the traces of battlefield actions that ooze from his equipment.

WW2 German MG42 Gunner
2022 年製作　1/10比例胸像
LIFE miniatures

聖杯騎士加拉哈德

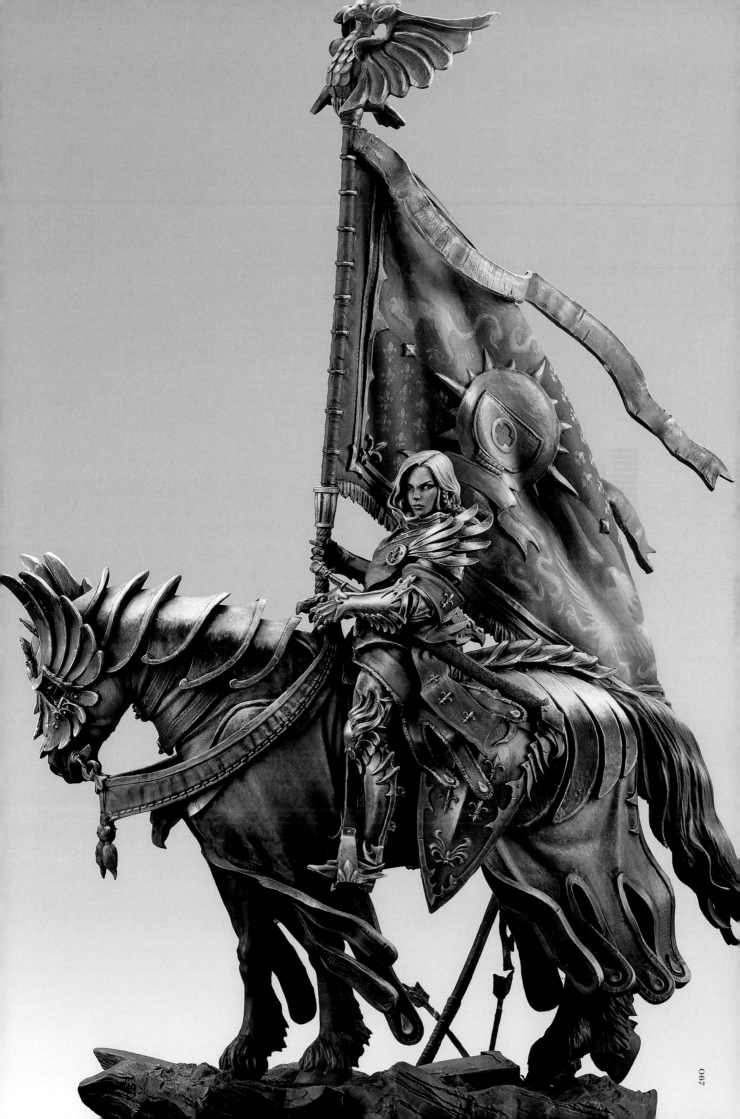

將樹脂化為金屬的 NMM 奇妙魔法

通常塗裝時會在金屬部分使用金屬塗料上色。但是在微縮模型的塗裝世界中，並不使用金屬塗料，而是使用所謂的 NMM（非金屬色金屬）技法塗裝。村上圭吾的作品幾乎都使用這個方法完成金屬部分的塗裝。另外，這次在作品中也嘗試了新的挑戰。

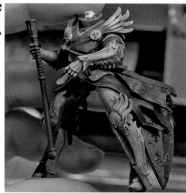

Day.1

▲由於零件小，數量又多，所以很小心地暫時組裝。而騎士手持旗幟的旗把和馬匹需相互遷就，所以花了一些時間調整。打底時只使用黑色的底漆補土。

Despite its small size, this particular kit has many parts, making pre-assembly all the more important. Take extra care so that the knight's flagpole won't interfere with the horse. Base primer was sprayed using only a black surfacer.

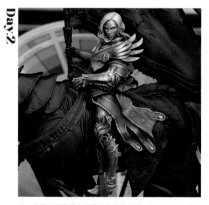

Day.2

▲一直使用顯微鏡處理臉部的塗裝作業。盔甲部分一邊留意光源，一邊使用 NMM 技法描繪出基本雛型。裝飾配件等同樣留意光源並且添加打亮細節。

The knight's face was painted with the aid of a stereo microscope. Her armor received a very rough layer of color utilizing the non-metallic metal technique. Make sure they all align with the direction of the (imaginary) light source.

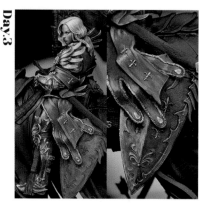

Day.3

▲描繪盔甲部分的同時，也開始描繪盾牌。雖然只是大概塗裝，但是已描繪出明顯的打亮細節。

Work continues with her armor and the shield. This is still in a very early stage, but the directions of the highlights are clearly drawn on.

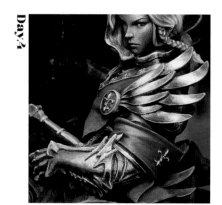

Day.4

▲這裡在盔甲重疊塗上綠色，目的是為了表現映照在盔甲上的自然風景。這是這次塗裝的挑戰嘗試。

The green colors painted experimentally on the left side of her armor plates represent a reflection of her surrounding scenery.

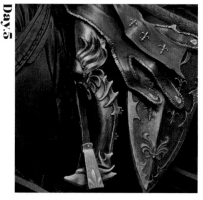

Day.5

▲讓倒影的綠色映照在腳邊周圍。想像人物模型所處的周圍環境，構思描繪出盔甲各處反光映照的樣子。

More greens were painted on the lower surfaces of her armor plates. They are painted not randomly but with a clear image of what her outside world looks like.

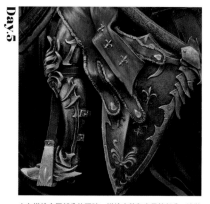

Day.5

▲在描繪金屬部分的同時，描繪皮革和皮帶等部分。塗裝時特別留意以不同於金屬的描繪手法作業。

Parts made from other materials, such as leather and fabric, are also being worked on. Care is taken to differentiate these areas from the metallic surfaces painted with non-metallic metal techniques.

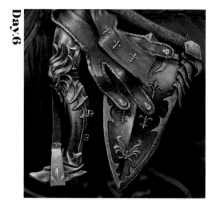

Day.6

▲接著也在盾牌部分描繪出倒影。另外，也持續描繪旗把等與騎士相關的其他部分。

The shield received the same treatment of painting on the reflective scenery, just like the rest of the armor plates.

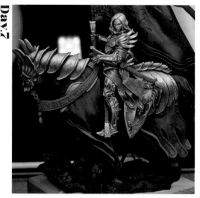

Day.7

▲開始描繪馬匹的塗裝。與騎士相同先大致上色，掌握整體樣貌。

The painting of the horse begins with similar steps taken earlier on the knight. The horse first receives very rough base colors.

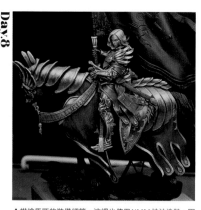

Day.8

▲描繪馬匹的裝備細節。這裡也使用 NMM 技法塗裝，因此要和騎士的金屬亮澤保持一致性。這裡發現另一邊塗裝不夠仔細，決定隔天先休息一天。

Make sure that armor plates on the horse have the same reflective surfaces as the knight's armor. The other side of the sculpture is mostly unpainted, but Murakami decided to take a day here.

Day.9

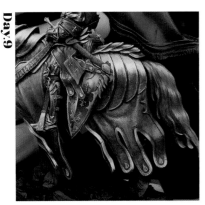

▲休息一天，重振精神。開始塗裝馬匹的臀部以及尾巴，並且描繪騎馬的服裝細節，塗裝過程中不斷確認整體的質感。

After a day off from painting, the tail end of the horse receives a detailed paint job. The decorative garment of the horse is also painted with extra care taken to replicate the fabric-like texture.

Day.10

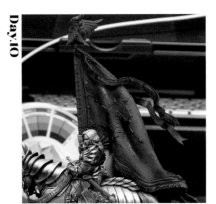

▲終於輪到大型旗幟的塗裝。先大概完成各區塊不同顏色的塗裝，確認整體的樣貌。

Finally, the work begins on the battle flag. As with every other segment, the flag is painted roughly at the beginning.

Day.11

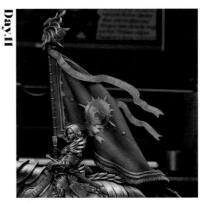

▲因為是黑色打底，所以總是無法呈現出理想的顯色度，不斷重疊塗色添加筆觸描繪至希望的色調。這裡不斷反省使用黑色打底的原因，一邊持續塗裝。

Since the flag was painted with a black primer, the brightness of the colors did not come out as originally intended. This was an important lesson for Murakami, and he corrected his error by overlaying multiple layers of colors until the desired brightness was reached.

Day.11

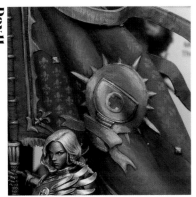

▲開始描繪旗幟的圖案。反覆細碎的圖案，使塗裝作業變得有點單調乏味。

The painting of decorative patterns of the battle flag starts. This is a tedious yet important step.

Day.12

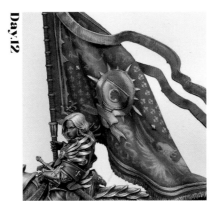

▲持續描繪旗幟，但是漸漸陷入麻木無感的精神狀態，所以隔天又再次休息一天。

The paint job on the flag continues. Murakami felt like going insane after several hours of painting these patterns and decided to take another day off the next day.

Day.13

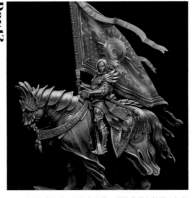

▲來到拍照確認並且調整的作業。變換背景色拍照，仔細確認。利用背景色的改變，有時會呈現不同的樣貌，而有新的發現。

The process of photographing, checking for errors, and correcting the detail begins. Switching the background from white to black can change the overall impression and sometimes bring new prospects.

Day.14

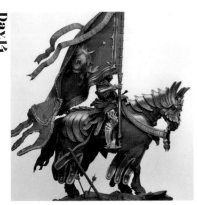

▲修正時主要針對塗裝不太仔細的另一側。重疊添加筆觸，希望呈現比正面暗一個色調的感覺。

Day 14 was spent painting and correcting the right side of the figure. Overall, this side is painted one step darker than the left/front side.

Day.15

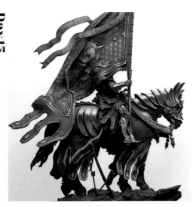

▲隔了約一週的時間再次塗裝。隔了一段時間重新觀看作品，就很容易發現沒有察覺或不滿意的地方。因為恢復了作業熱情，也開始處理旗幟另一面的圖案。

After taking a week off, Murakami was able to observe the piece with a fresh mind. The decorative patterns of the rear side of the battle flag are painted.

Day.16

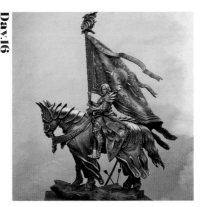

▲試著以畫布為背景塗裝，並且一起拍照。在確認的階段調整了眼睛周圍、左臉頰的陰影和頭髮等部位。

A simple background was painted on a canvas, and photographing session commenced. Several corrections around the eyelids left cheek shadows, and her hair was made.

069

by Kazuya Yoshioka

何謂村上圭吾作品備受矚目的秘密？
連微縮模型大師都嫉妒的天賦——
立體分明的「光」「影」描繪

村上圭吾塗裝的人物模型色彩層層疊疊，醇厚有韻味，引人入勝，然而塗裝色調不像歐洲塗裝般給人昏暗的感覺，長時間細細品味也不會感到乏味無趣。我認為他的作品風格比較偏向彩度低的樸質色調。而彩度低的作品很容易讓人覺得沉穩單調，但是村上圭吾塗裝的人物模型本身卻能夠呈現出強烈的個性。箇中原因究竟藏在何處？我決定仔細端詳村上圭吾的作品。然後我在其作品中發現，他會在增添作品魅力的鼻子、頭髮和下巴等造型部位，分別添加程度不一的「陰影」。

「陰影」可以讓人感受到光的存在，讓物件的形狀鮮明，強調出特定的部位，或營造柔和雅致的氛圍，有時甚至讓作品呈現出令人震撼的感受。在人物模型巧妙描繪出由照明構成的陰影效果，會讓模型本身擁有強烈的存在感。軍事人物模型中，會很理所當然地將因為遮蔽而未照射到光線的「陰暗」，當成塗裝的第一個步驟。但是卻很少描繪由光線照射所產生的「影子」細節。這一方面也是受限於觀賞角度的關係，而影子在形狀、位置和色調的描繪

設定非常困難，一旦描繪得不自然，就會變成令人感到突兀的塗裝作品。要在立體作品上描繪自然細膩又不違和的影子，需要有一定的美感與領悟，但是村上圭吾的作品卻輕而易舉地跨越這道障礙。這不正是塗裝師具備實力的證明。

村上圭吾的作品以塗裝豐富了塗裝造型擁有的世界觀，而且還進一步加以擴展，提升其魅力。他對於美化造型的關鍵，擁有相當敏銳地鑑識能力，這一點非常適合以3D軟體精巧設計的人物模型。村上圭吾以「光」「影」為武器，描繪出不同領域的人物模型，包括風格粗曠的軍事系列到流行角色類型，村上風格的全能塗裝表現，今後依舊會讓人更加目不轉睛。

吉岡和哉
世界著名的頂尖微縮模型師，並且擔任
『Armour Modelling』的顧問。著作
有『戰車情景模型製作教範』和『吉岡
和哉AFV模型進階製作教範』（大日本
繪畫）。

Kazuya Yoshioka is a world-famous
AFV diorama builder and an advisor to
"Monthly Armour Modelling". He is also
the author of "Diorama Perfection" and
"Tank Think Tank".

All the figures painted by Murakami are eye-catching with their layers of rich and deep colors. Yet, they appear to have zero dullness typically seen in other figures painted in a similar European style. You simply can't get bored looking at his works. The most striking feature of Murakami's works is his unique selection of colors. While sculptures with dim colors tend to become monotonous, the figures painted by Murakami somehow maintain a strong presence. I took some time trying to figure out why this is and came to a conclusion after carefully observing his works. I noticed that in figures painted by Murakami, every aspect, such as nose, hair, chin, etcetera, casts its own "shadow."

Shadows, as important as light, can accentuate an object's shape or emphasize a specific area of the figure if cleverly utilized. Shades can create a soothing, gentle atmosphere if cast lightly. It could also give an impactful look to your painting, depending on the strength and tone of the shadow. Figures that skillfully manipulate the effects of shadows will give strong impressions on the viewers. When painting military figures, it is not uncommon to replicate naturally cast shadows. However, it is rare to draw in shades that are created by artificial light and highlights. Of course, by replicating these shadows, you also limit the viewing angle. As you know, figures painted with non-metallic metal technique might look a little odd depending on the direction you view from. It takes immense skill to overcome this drawback, yet Murakami draws shadows on a three-dimensional level without any difficulty. This is the very proof of Murakami being a skillful painter.

Murakami interprets the world and the environment in which these sculptures live and expands them through his unique painting style. His ability to accurately identify the most "juicy" bits of a figure is a perfect match for sculptures created with 3D software. His all-round painting style, cleverly combining the use of light and shadow, can be adopted in every genre, from military subjects to cute, pop characters. We sure can't take our eyes off Murakami and his works in the future.

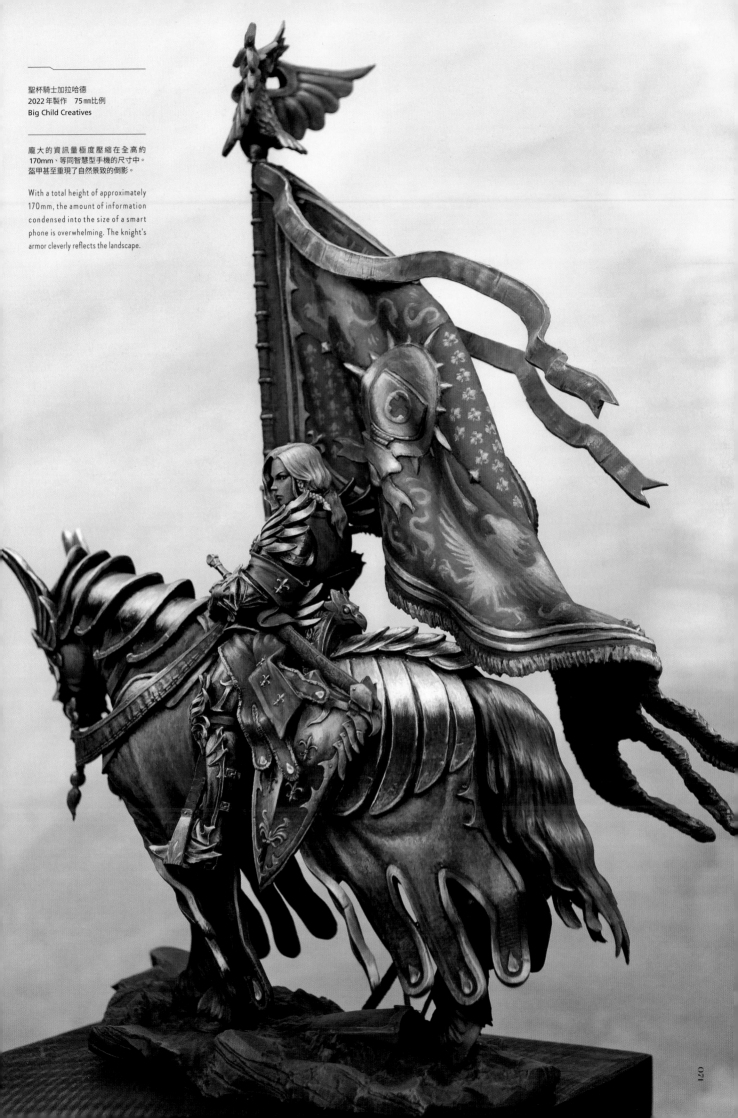

聖杯騎士加拉哈德
2022年製作　75mm比例
Big Child Creatives

龐大的資訊量極度壓縮在全高約
170mm、等同智慧型手機的尺寸中。
盔甲甚至重現了自然景致的倒影。

With a total height of approximately
170mm, the amount of information
condensed into the size of a smart
phone is overwhelming. The knight's
armor cleverly reflects the landscape.

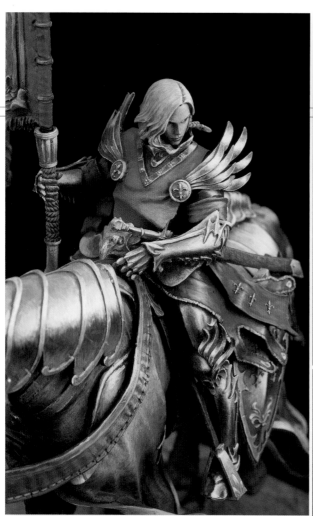
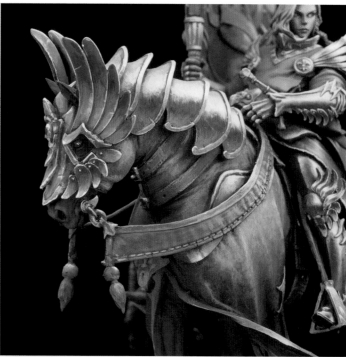
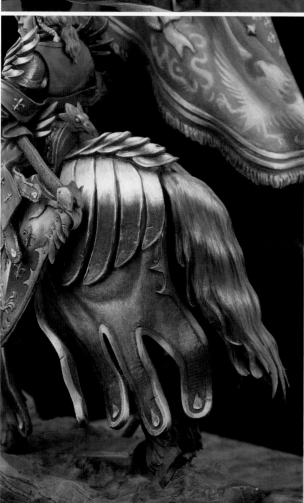
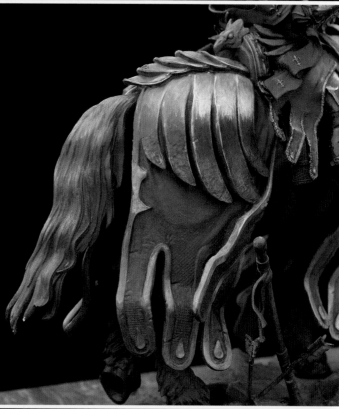

by MA-man

新銳女性塗裝師透過村上圭吾作品所見的「寧靜與雅致」

「猶如人物安靜佇足眼前」

這是我第一次觀看村上圭吾作品「戴珍珠耳環的少女」（右下方的照片）時，內心的真實感受。我第一次看到村上圭吾的作品是在Twitter，當時我剛開始接觸到人物模型塗裝沒多久。我記得那時自己驚嘆「好像繪畫的質感！」畫面中村上圭吾的作品彷彿實際出現在我眼前，這股氛圍讓我不自覺停下手邊的動作。

我曾經和村上圭吾共同在塗裝活動上展示因而相互認識。他的塗裝作品曾讓我誤以為他是一位沉默寡言的人，但是完全不是！在與他交談後，我發現他是一位相當開朗的人，打從心底喜歡塗裝而且是人物模型塗裝，其人品都體現在作品中。我在那時觀看了他的作品，作業相當細膩，但是觀看整體時又散發著沉穩一致的色調質感，讓人感到「寧靜與雅致」。

而令我驚訝的是精細度之高，透過實體顯微鏡下觀看的世界完全不同於肉眼所見的世界，所以我記得這讓不使用顯微鏡的我感到既新奇又充滿興趣。雖然我描繪油畫、數位插畫或一般1/7比例人物模型塗裝時，曾使用過放大鏡，但卻不曾使用顯微鏡觀看描繪的內容。如此講究、透過顯微鏡觀察輔助，達到如此細膩的運筆，才會呈現出村上圭吾獨特驚人的美感。

透過繪畫紋理，察覺創作者透過筆尖描繪的各種細節，從這個角度來鑑賞同為塗裝師的作品相當有趣，可享受到「作業」以及「成品」的雙重樂趣。如今我主要塗裝和展示的是人物模型，但原本描繪的是油畫，所以我想慢慢增加像村上圭吾般塗裝方式的作品，因此得多看看村上圭吾的作品，並且竊取其中的優點（笑）！翻閱這本書的各位，應該也抱持著相同想法觀看作品吧！

MAman
美術大學畢業的人物模型塗裝師，目前是非常受到歡迎的YouTuber。本身有在經營YouTube頻道「MAman ch。」，頻道登錄人數已高達22.8萬人（截至2022年6月）。擁有美術教師執照和書法教師執照，是目前最受注目的一位女性塗裝師。

MA-Man is a figure painter active on the YouTube platform (figure brush painting channel "MAman") with over 200 thousand subscribers. With qualifications as an art teacher and a calligraphy instructor, she is one of the most popular figure painters in the world today.

"It was as if she was really there, standing quietly.. right over there."
That was the honest impression I first had when looking at Murakami-san's work, the "Girl with a Pearl Earring." It was about the same time I started painting figures myself, and I remember being surprised by his work's picturesque texture. It was astonishing, and I couldn't help but keep staring at his work on my Twitter feed as if the real thing was right in front of me.
I had the opportunity to meet Murakami-san at a painting event we both attended together. I always thought of him as a quiet, calm person, but that was not the case! Murakami-san has a bright personality, and I could immediately tell he enjoys figure painting from the bottom of his heart. I was able to see his paintings at the event. While his works are full of detail with many different colors, the entire piece was still very cohesive. I felt that serenity and elegance co-exist within his figure paintings.
What also surprised me was the resolution (the level of detail) with which he paints. The world seen through a stereo microscope is at a completely different level compared to the naked eyes, and that was very refreshing for me, who has never used such microscopes before. I sometimes used a simple magnification loupe for painting oil paintings and 1/7 scale figures, but nothing like what Murakami-san uses. Murakami-san can move his painting brush so delicately through his stereo microscope, which adds a certain uniqueness to his painting style.
As a painter myself, I could tell the techniques and brush strokes Murakami-san used by looking at his works. In that sense, I enjoyed his works twice... first as a viewer and second as a fellow painter, analyzing how these masterpieces were completed. I plan on incorporating his painting style into some of my future projects. To do that, I need to study more of his works and steal all his techniques from him. (laughs) I am sure the readers of this book also appreciate Murakami-san's works the way I do.

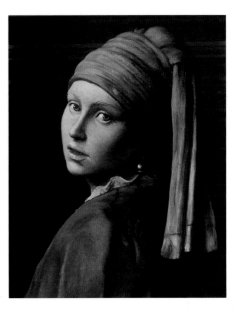

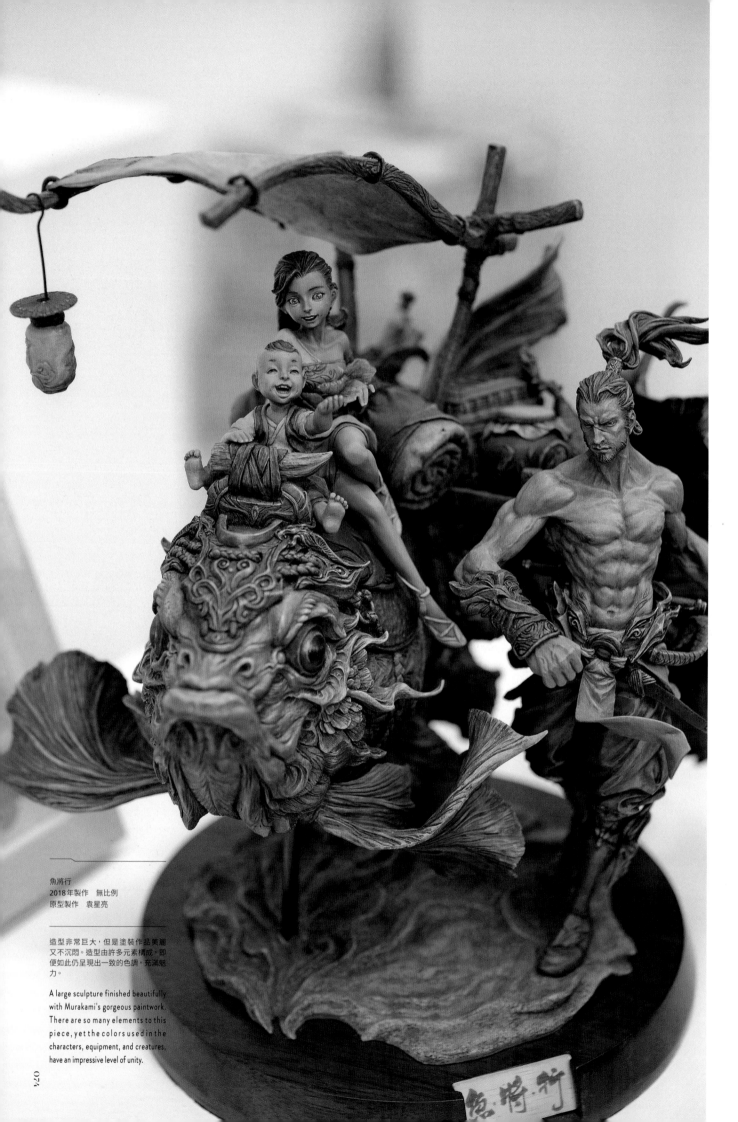

魚將行
2018年製作　無比例
原型製作　袁星亮

造型非常巨大，但是塗裝作品美麗
又不沉悶。造型由許多元素構成。即
便如此仍呈現出一致的色調，充滿魅
力。

A large sculpture finished beautifully
with Murakami's gorgeous paintwork.
There are so many elements to this
piece, yet the colors used in the
characters, equipment, and creatures,
have an impressive level of unity.

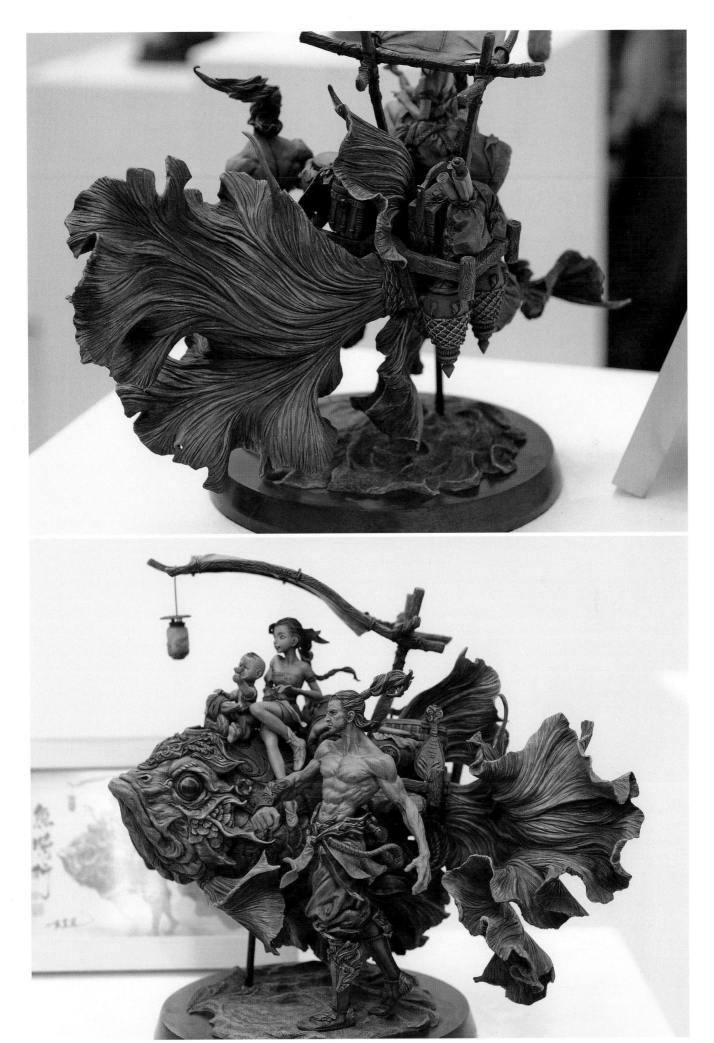

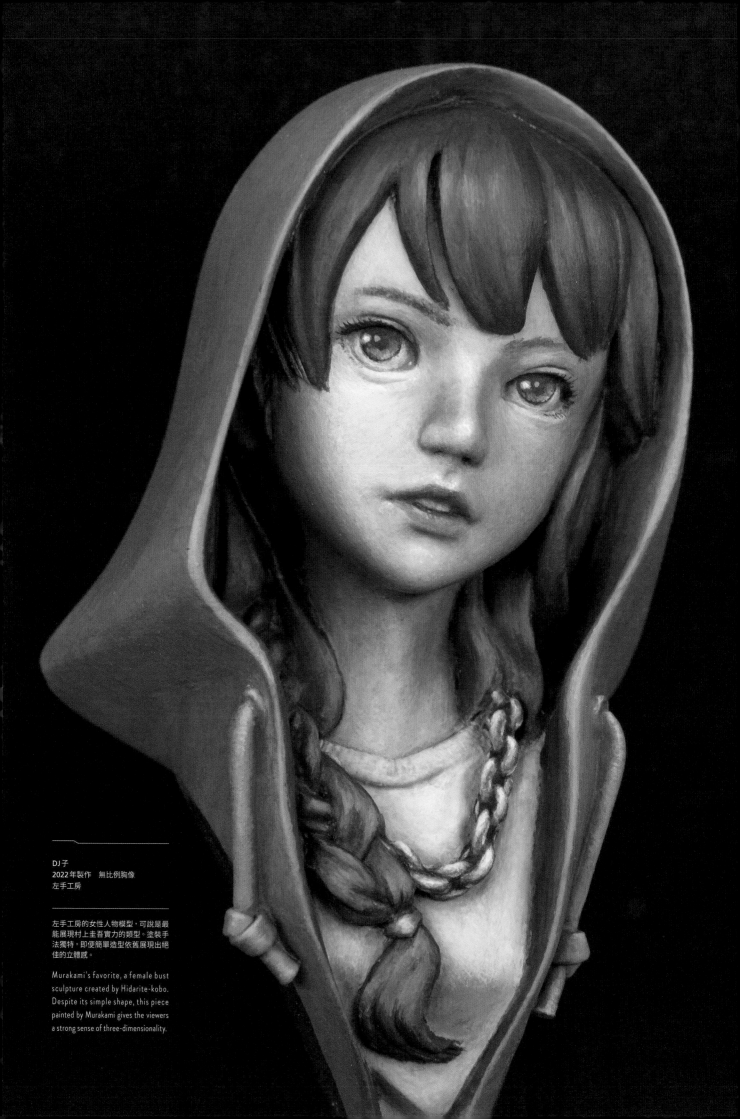

DJ子
2022 年製作　無比例胸像
左手工房

左手工房的女性人物模型，可說是最
能展現村上圭吾實力的類型。塗裝手
法獨特，即便簡單造型依舊展現出絕
佳的立體感。

Murakami's favorite, a female bust
sculpture created by Hidarite-kobo.
Despite its simple shape, this piece
painted by Murakami gives the viewers
a strong sense of three-dimensionality.

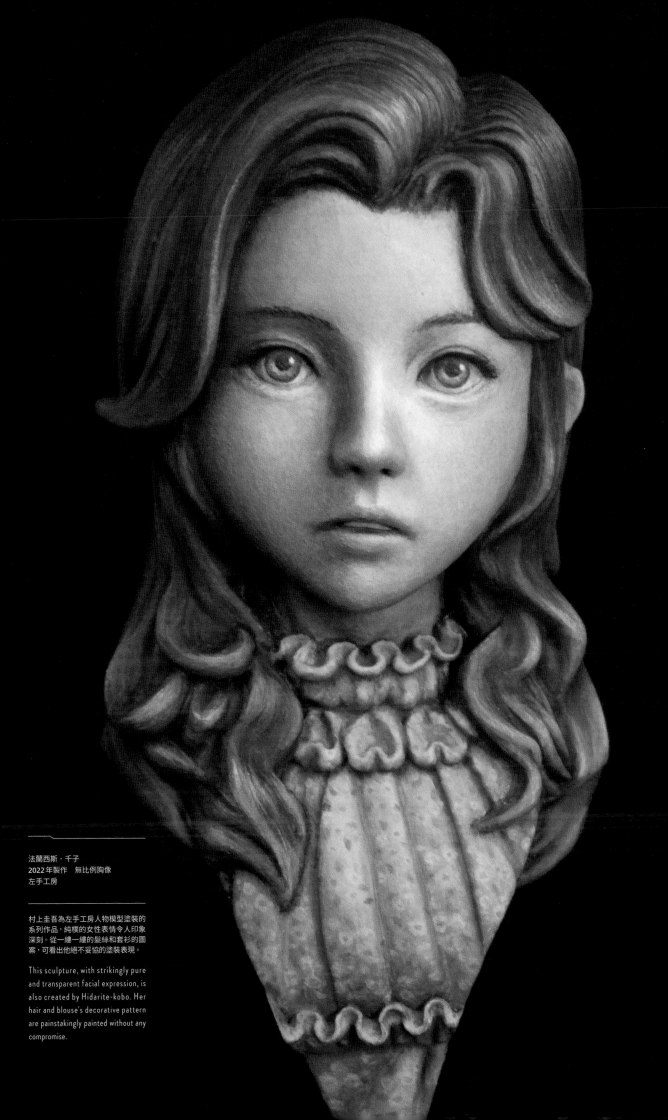

法蘭西斯・千子
2022 年製作　無比例胸像
左手工房

村上圭吾為左手工房人物模型塗裝的
系列作品，純樸的女性表情令人印象
深刻。從一總一縷的髮絲和套衫的圖
案，可看出他絕不妥協的塗裝表現。

This sculpture, with strikingly pure
and transparent facial expression, is
also created by Hidarite-kobo. Her
hair and blouse's decorative pattern
are painstakingly painted without any
compromise.

深夜的娥孃
2020 年製作　無比例胸像
左手工房

大家聽到飛蛾就會聯想到有毒，但是
這件人物模型卻絲毫沒有散發出這種
感覺，反而流露妖嬈魅惑的氛圍。

The word "moth" gives off a poisonous
image, but this figure somehow doesn't
give that impression at all. Instead, it
creates an alluring atmosphere.

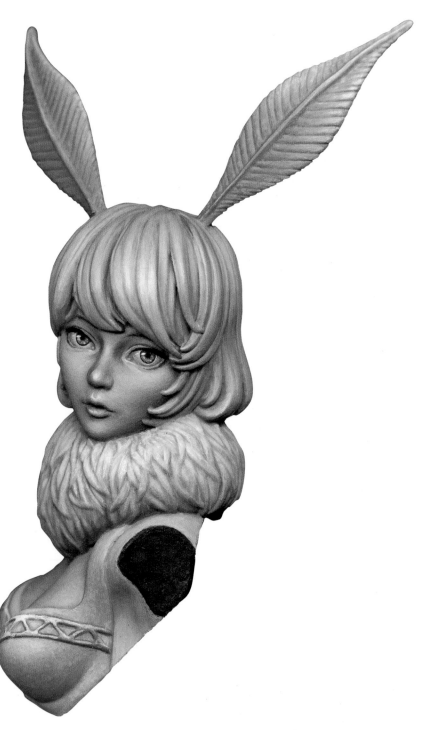

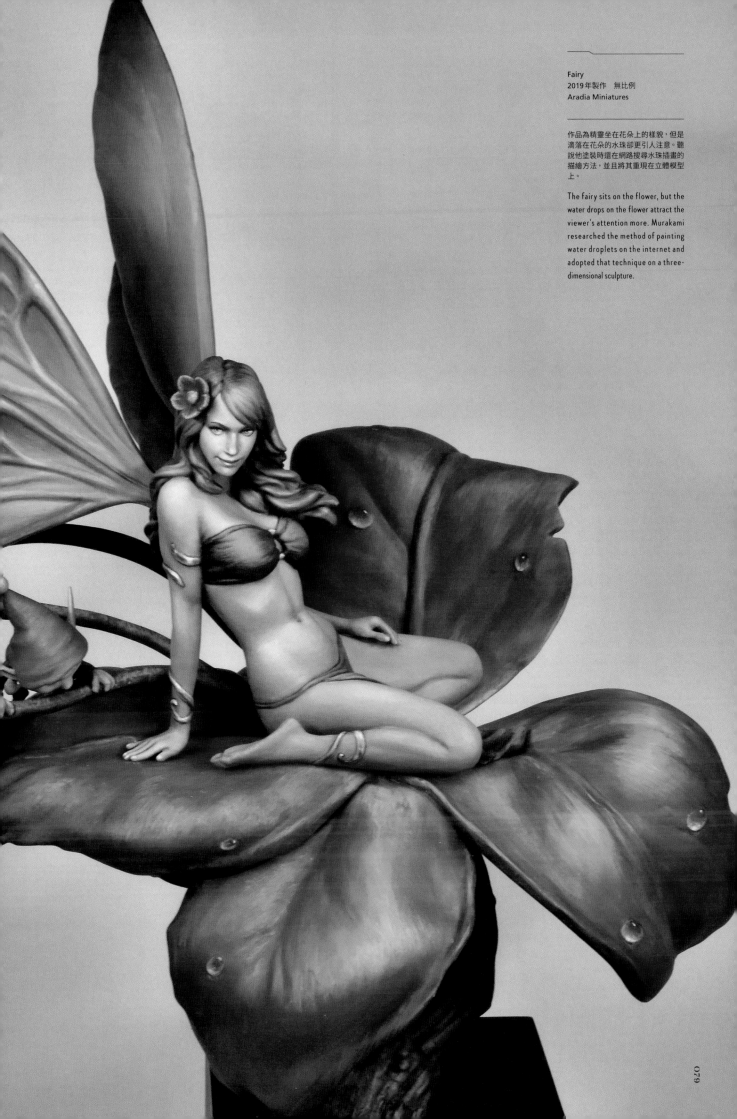

Fairy
2019 年製作　無比例
Aradia Miniatures

作品為精靈坐在花朵上的樣貌，但是
滴落在花朵的水珠卻更引人注意。聽
說他塗裝時還在網路搜尋水珠插畫的
描繪方法，並且將其重現在立體模型
上。

The fairy sits on the flower, but the
water drops on the flower attract the
viewer's attention more. Murakami
researched the method of painting
water droplets on the internet and
adopted that technique on a three-
dimensional sculpture.

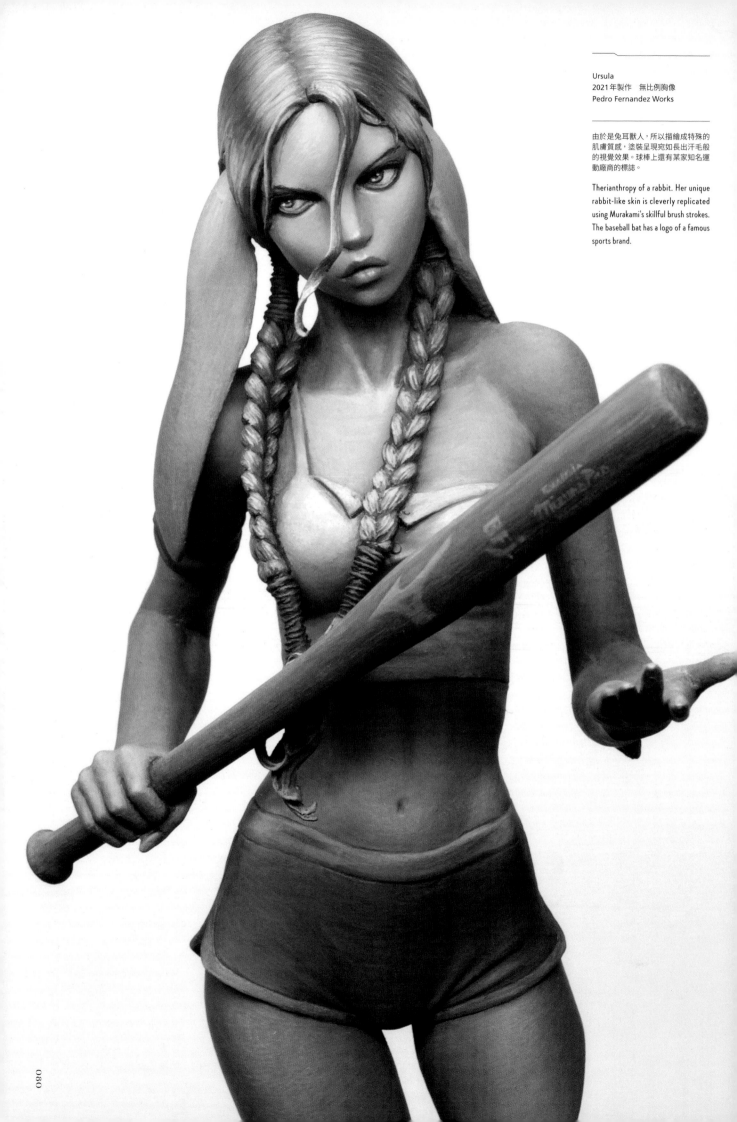

Ursula
2021 年製作　無比例胸像
Pedro Fernandez Works

由於是兔耳獸人，所以描繪成特殊的
肌膚質感，塗裝呈現宛如長出汗毛般
的視覺效果。球棒上還有某家知名運
動廠商的標誌。

Therianthropy of a rabbit. Her unique
rabbit-like skin is cleverly replicated
using Murakami's skillful brush strokes.
The baseball bat has a logo of a famous
sports brand.

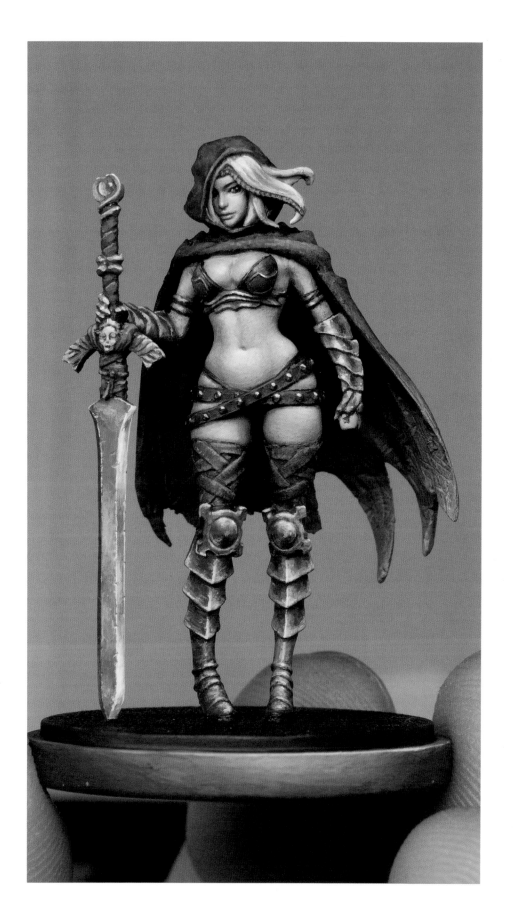

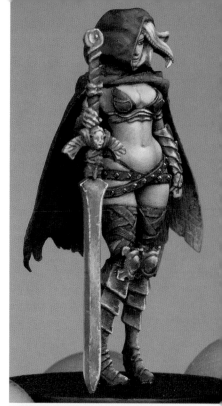

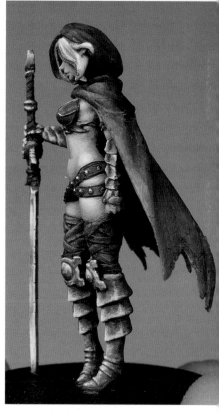

twilight Knight
2020 年製作　35mm比例
Kingdom death

尺寸非常迷你，但是村上流的塗裝絕
不會受限於尺寸。盔甲、劍，甚至底
座都用NMM技法塗裝。

The overall size of this figure is tiny,
but you can still see the presence of
Murakami's unique painting style. Even
the armor, sword, and pedestal are
finished with the non-metallic metal
painting technique.

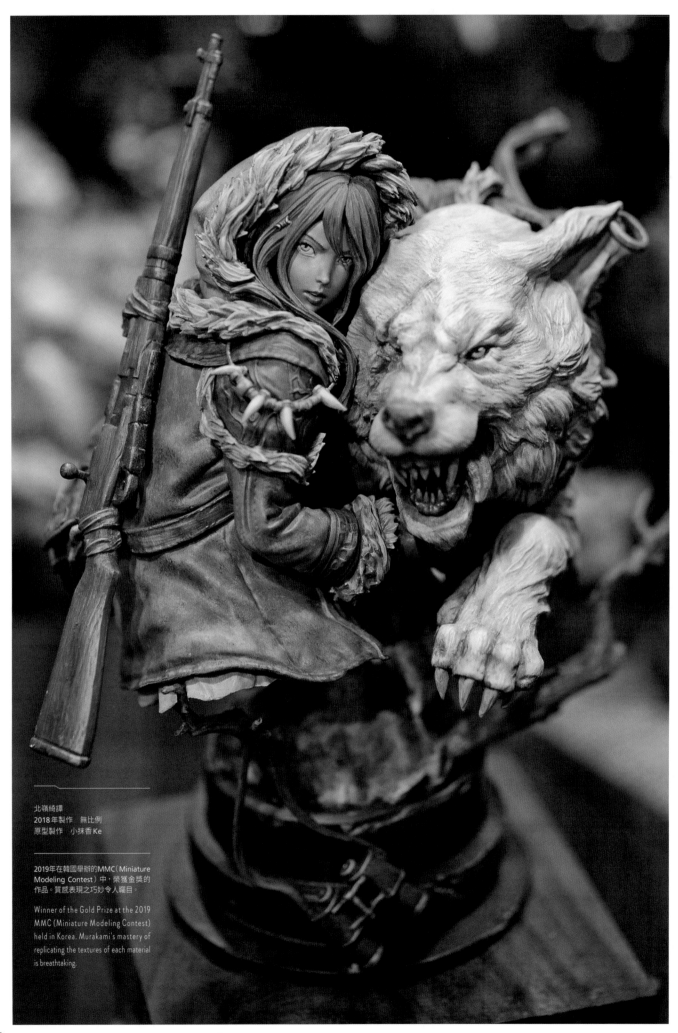

北嶺綺譚
2018 年製作　無比例
原型製作　小抹香 Ke

2019年在韓國舉辦的MMC（Miniature
Modeling Contest）中，榮獲金獎的
作品。質感表現之巧妙令人矚目。

Winner of the Gold Prize at the 2019
MMC (Miniature Modeling Contest)
held in Korea. Murakami's mastery of
replicating the textures of each material
is breathtaking.

The garden～Take your time～
2021 年製作　無比例
原型製作　藤本圭紀

女孩面頰鼓起的表情讓人物模型顯得
格外可愛。青蛙的質感，高高聳立的
蘑菇和皺褶，處處都展現出村上流的
講究。

A figure of a girl with an adorable pouty
face. Characteristics of Murakami's
unique painting style are visible all over
this piece.

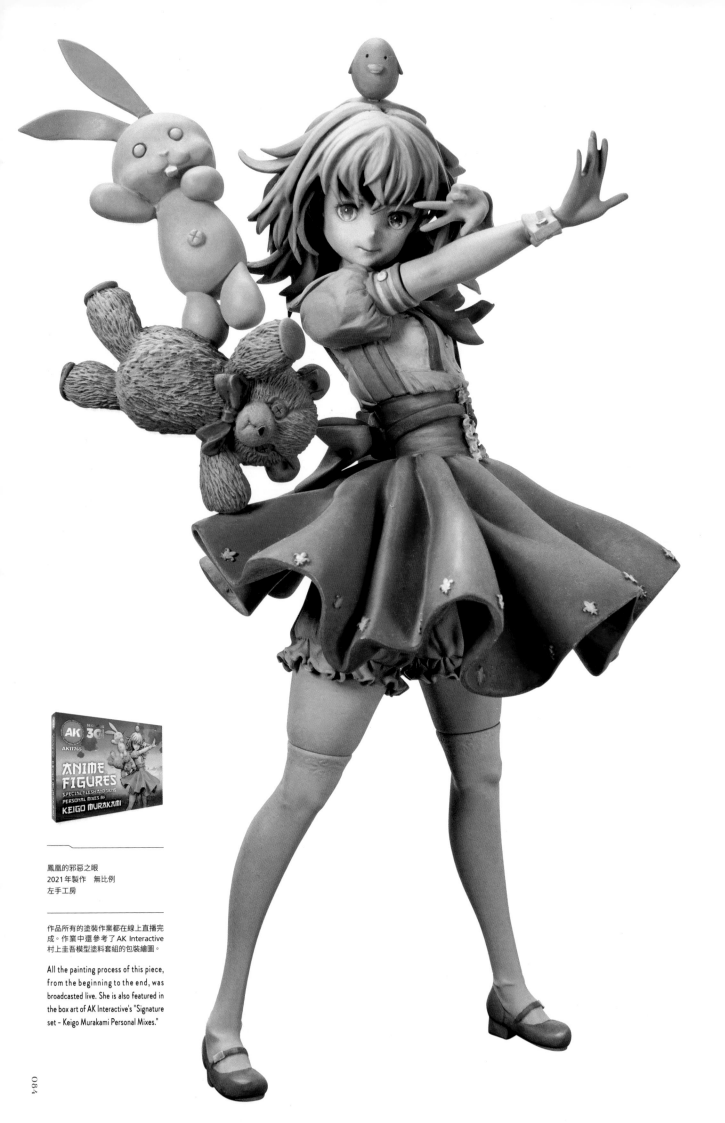

鳳凰的邪惡之眼
2021 年製作　無比例
左手工房

作品所有的塗裝作業都在線上直播完
成。作業中還參考了 AK Interactive
村上圭吾模型塗料套組的包裝繪圖。

All the painting process of this piece,
from the beginning to the end, was
broadcasted live. She is also featured in
the box art of AK Interactive's "Signature
set – Keigo Murakami Personal Mixes."

by Eduardo Fernandez

AK Interactive 總是不斷發掘世界各地擁有傑出才能的模型師，而村上圭吾絕對是其中一位。多年來我們持續關注他為人物模型賦予鮮活的生命，並且認為他展示的塗裝作品都具有極高的水準，對我們來說，大家都很榮幸能夠與村上圭吾合作共事。現在 AK Interactive 正銷售由村上圭吾精選的塗料套組「SIGNATURE SET-KEIGO MURAKAMI PERSONAL MIXES」，並出版了收錄他作品的人物模型雜誌「Tint Inc#3」。

若要我以個人的觀點來表示意見，我認為村上圭吾相當勤奮且擁有一顆開放的心，他還會積極協助想學習或了解他塗裝技巧的模型師。他的人物模型塗裝風格相當獨特，以自然平順的漸層表現調和整體作品的技巧獨一無二。他的作品沒有突兀之處，整體流露著和諧的調性。不論是奇幻題材、還是歷史素材，都不會失去他個人的風格和質感，可以努力將其體現在作品中。村上圭吾即便在這個領域的塗裝師中，也屬於頂尖的佼佼者，如果你想要「向傑出的大師學習」，他絕對是最佳人選，而且名符其實。

At AK Interactive, we are always attentive to the work of the most talented modelers in the world, one of them being Keigo Murakami, without a doubt. After years of appreciating and following his work, we have had the privilege of having him create a set of paints (SIGNATURE SET - KEIGO MURAKAMI PERSONAL MIXES) and collaborate with our figure magazine Tint Inc #3. On a personal level, we can say that he is a very hard-working and collaborative person, open to helping and teaching people who want to learn from his way of making art.

From an artistic point of view, Keigo certainly has a personal stamp. Little by little, we have been accustomed to works of a very high level characterized by their smoothness and harmony. There are no dissonant notes in his works, everything fits together, and he does it smoothly and naturally. Capable of facing both fantasy and historical works without losing their imprint and their quality. Keigo Murakami is one of the great exponents within our hobby today and an essential if what you are looking for is to learn from the best.

連微縮模型塗裝的發源地，來自西班牙的廠商也青睞有加

Eduardo Fernandez
AK Interactive 人物模型部門的總負責人，也是 Tint Inc 雜誌的總編輯，投注許多心力在軍事與人物模型的製品、材料和出版，與村上圭吾私交甚篤。

The head of the figure department at AK Interactive and the chief editor of the "Tint Inc." magazine. Ferández has a strong friendship with Keigo Murakami as well.

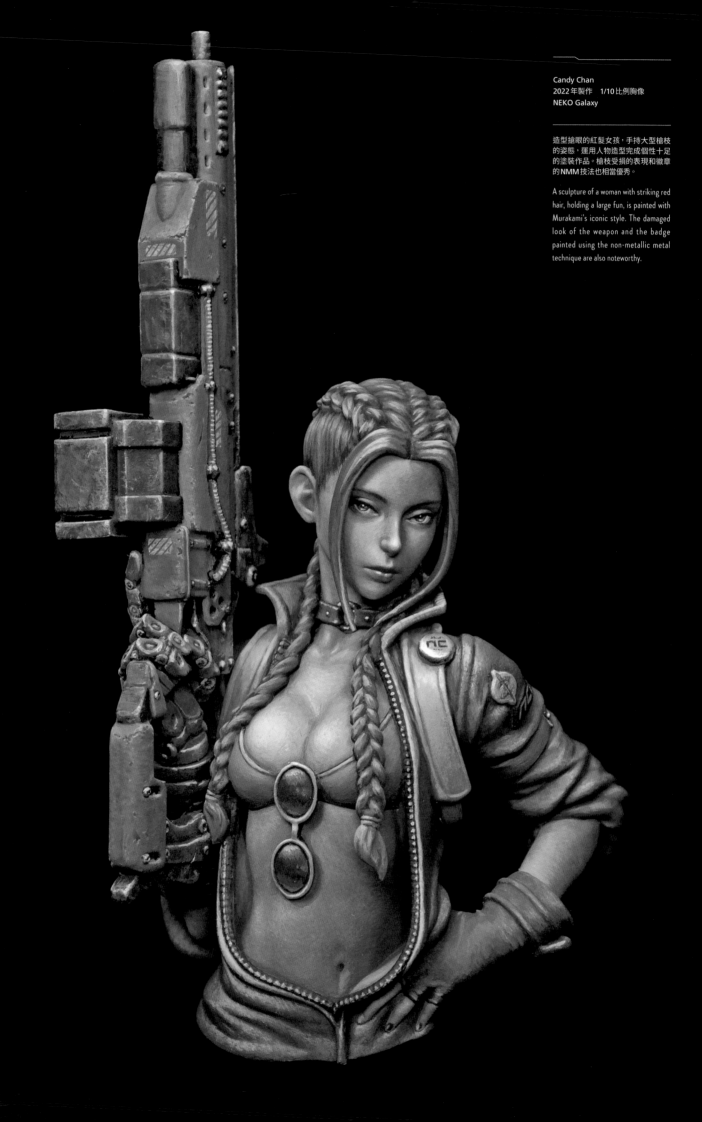

Candy Chan
2022 年製作　1/10 比例胸像
NEKO Galaxy

造型搶眼的紅髮女孩，手持大型槍枝的姿態，運用人物造型完成個性十足的塗裝作品。槍枝受損的表現和徽章的NMM技法也相當優秀。

A sculpture of a woman with striking red hair, holding a large fun, is painted with Murakami's iconic style. The damaged look of the weapon and the badge painted using the non-metallic metal technique are also noteworthy.

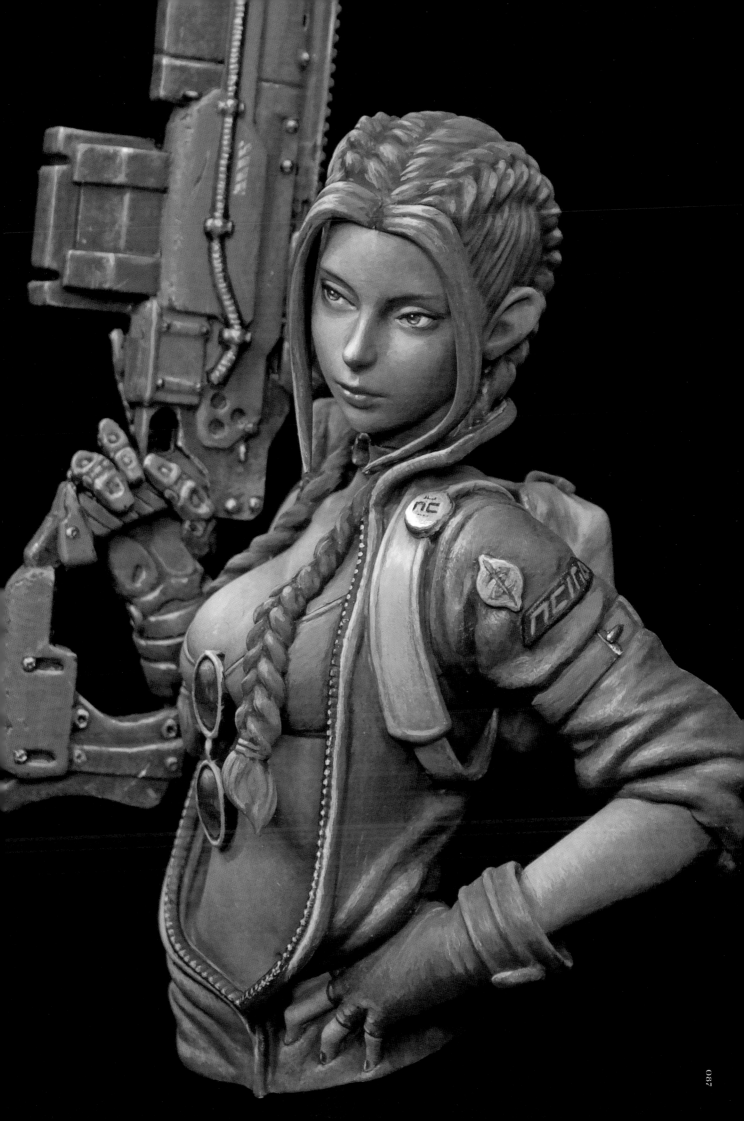

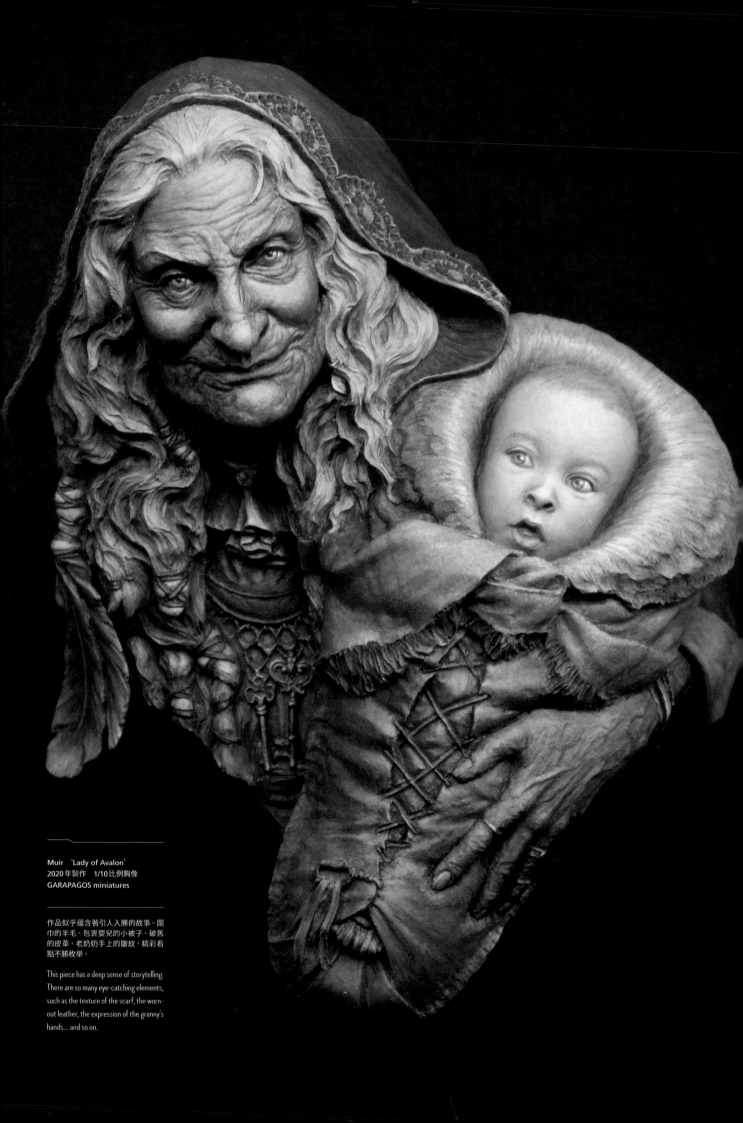

Muir 'Lady of Avalon'
2020 年製作 1/10比例胸像
GARAPAGOS miniatures

作品似乎蘊含著引人入勝的故事。圍
巾的羊毛、包裹嬰兒的小被子、破舊
的皮革、老奶奶手上的皺紋，精彩看
點不勝枚舉。

This piece has a deep sense of storytelling.
There are so many eye-catching elements,
such as the texture of the scarf, the worn-
out leather, the expression of the granny's
hands... and so on.

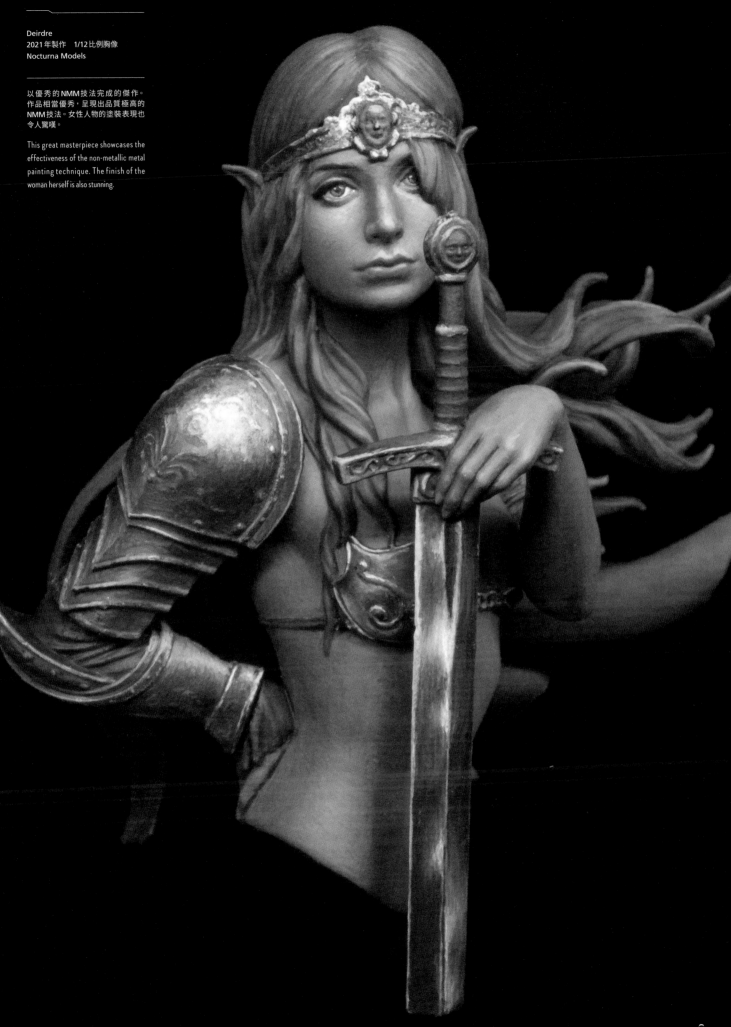

Deirdre
2021年製作　1/12比例胸像
Nocturna Models

以優秀的NMM技法完成的傑作。
作品相當優秀，呈現出品質極高的
NMM技法。女性人物的塗裝表現也
令人驚嘆。

This great masterpiece showcases the
effectiveness of the non-metallic metal
painting technique. The finish of the
woman herself is also stunning.

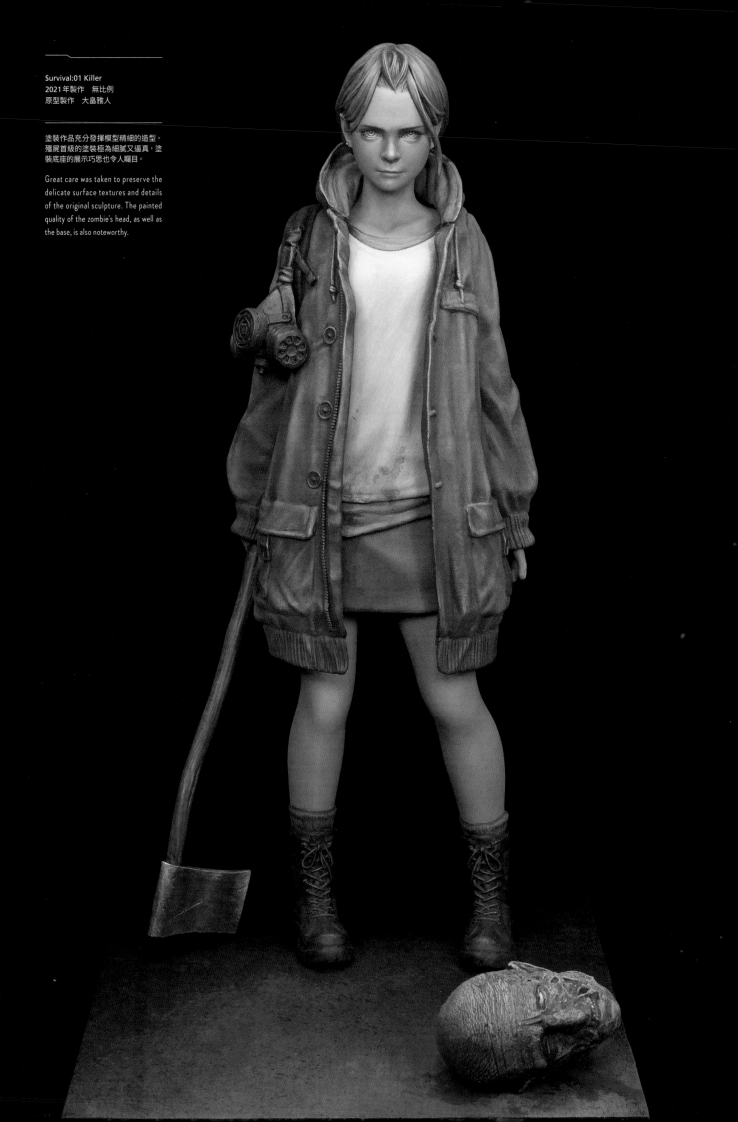

Survival:01 Killer
2021年製作　無比例
原型製作　大畠雅人

塗裝作品充分發揮模型精細的造型。
殭屍首級的塗裝極為細膩又逼真，塗
裝底座的展示巧思也令人矚目。

Great care was taken to preserve the
delicate surface textures and details
of the original sculpture. The painted
quality of the zombie's head, as well as
the base, is also noteworthy.

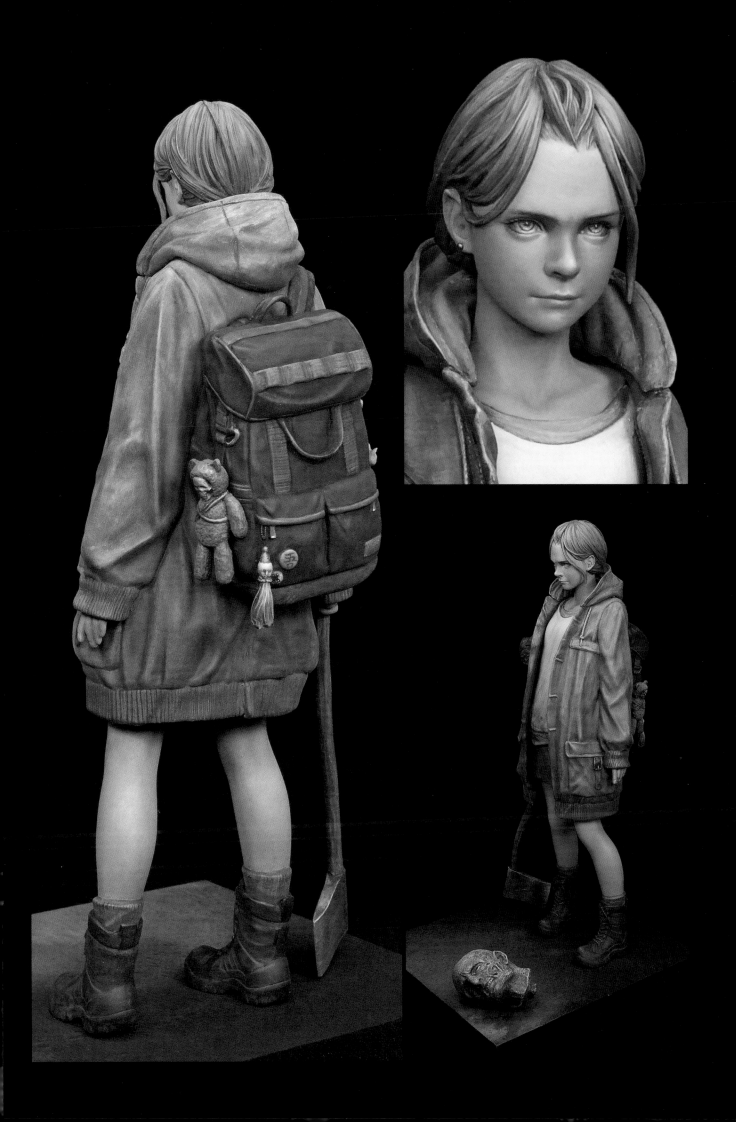

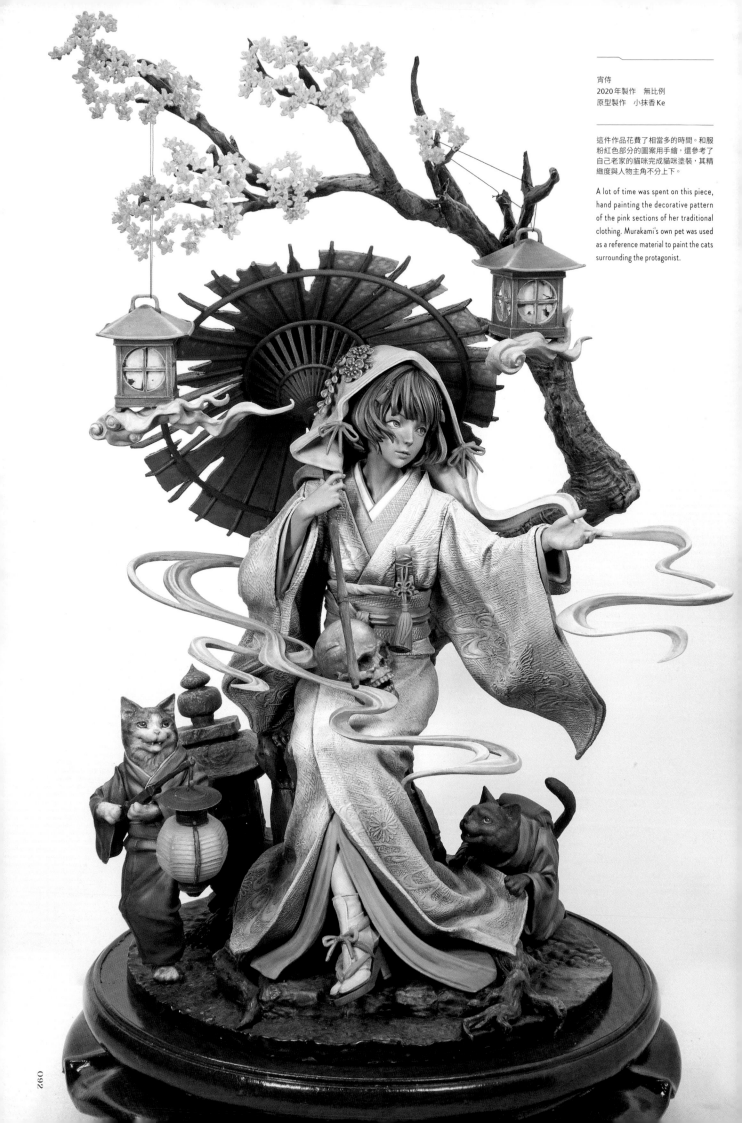

宵侍
2020年製作　無比例
原型製作　小抹香Ke

這件作品花費了相當多的時間。和服
粉紅色部分的圖案用手繪，還參考了
自己老家的貓咪完成貓咪塗裝，其精
緻度與人物主角不分上下。

A lot of time was spent on this piece,
hand painting the decorative pattern
of the pink sections of her traditional
clothing. Murakami's own pet was used
as a reference material to paint the cats
surrounding the protagonist.

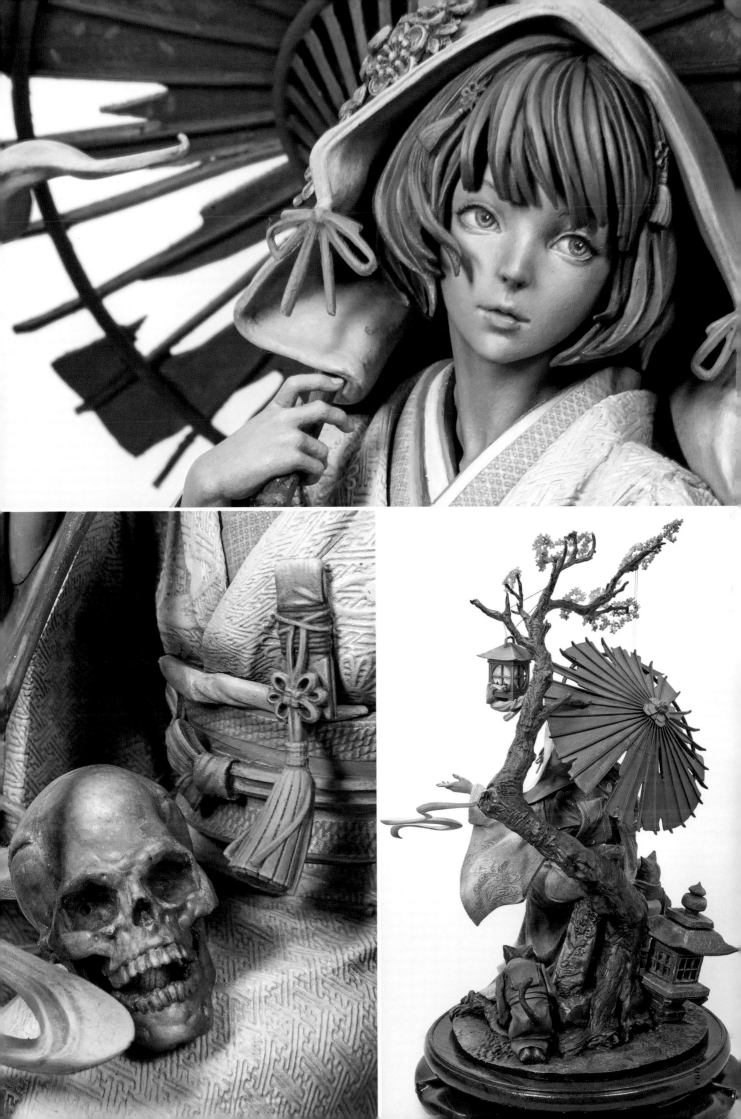

by Hiroshi Tagawa

　我第一次遇見村上圭吾是在大阪舉辦的模型活動 Modeler's Festival 會場，而且是透過朋友小川先生的介紹。那時我正開始接觸人物模型塗裝，我們兩人才剛加入小川先生舉辦的同好會。我記得那時小川先生表示：「我正在教他塗裝！」我對村上圭吾作品的第一印象是，「啊，這個人以後一定會越來越厲害」。作品給人相當真誠的感覺，而且我認為他還有很大的成長空間。一如大家所知，我是會直接向對方說出內心感受的人，但我當時未能向村上圭吾言明。當時，該怎麼說，我覺得他沒有給我說話的機會（笑）。

　我自己的作品總是著重於「華麗」，所以塗裝打底時多使用白色、紅色或粉紅色。但是村上圭吾的塗裝都是從黑色底漆補土開始。如果打底用黑色，上面不論疊加上多鮮豔的顏色，都會降低塗裝色調的顯色度，而給人暗沉的感覺。我每次看到都覺得這種作法終究是白費功夫。因此過去在靜岡模型秀的展示會上見面時，我曾建議他：「打底不一定要全部塗成白色，但是想展現的部分、想突顯的部分，打底最好使用白色或紅色。」但是我一邊說一邊想這個人絕對不會聽從建議（笑）。我認為村上圭吾的腦中對於人物模型塗裝已經有很清晰的輪廓樣貌，而且有自己想描繪的塗裝表現，並且對此相當執著與重

視。從好的層面來看，他可說是有所堅持講究的人。

　我不太知道國外的模型師風格，但是我總覺得村上圭吾的作品是不是受到歐洲人物模型塗裝師的影響。他塗裝的方法是一邊留下陰影又一邊疊加明亮色調，也就是會在明亮部分添加打亮。若使用這種方法，最後不就變成打亮處最亮的部分全都是白色。這種說法或許有點誇張，但是肌膚、鞋子、服裝的打亮部分全都是白色。不過村上圭吾作品打亮部分的質感表現實在，而且都表現出各自應有的色調，呈現極為自然的樣子。

　一如我方才所說，我想做出華麗的作品。但其實寫實類和動漫類在塗裝表現並不相同。動漫類要留意表現得更加明亮。村上圭吾的作品和華麗感相反，呈現堅硬、厚實和厚重感。我最近發現村上圭吾擔任國外廠商的塗裝老師（商品範本），就連動漫類角色都用相同的方法塗裝。若以一般認知思考，塗裝會隨每種類型而有所不同，但是他完成的動漫角色塗裝給人厚重感，難道不會讓人覺得「怪怪的」嗎？然而他的作品卻完全沒有塗裝失敗的感覺。雖然完成的塗裝作品與原型師的構想可能大相徑庭，但卻奇妙地契合相融。不但沒有塗裝失敗，反而讓人陷入這非比尋常的感受。作品沉穩厚實卻隱隱流露華

麗氣派的感覺。

　如果你問我是否可用相同的方法塗裝，我可能會說我不是做不到，而是我不想這樣塗裝（笑）。原因終究歸結在我們對於塗裝的追求並不相同。即便看了村上的作品，也絕對看不到有我的影子，我也同樣不會受到他的影響。若真要說相似點，或許可以這麼說，我的作品是女性取向的華麗，村上的作品是男性取向的華麗。

I first met Mr.Murakami at Modeler's Festival, an annual hobby modeling event held in Osaka. I was introduced to him by an acquaintance, Mr.Ogawa. At that time, I had just begun painting figures, and so was Mr.Murakami under Mr.Ogawa's painting club. I remember Mr.Ogawa saying, "I am teaching him." My impression of Mr.Murakami then was that he would get better and better and would quickly become a master painter. As you may know, I am the type of person who is not shy to express my opinion. I knew Mr.Murakami had a lot of room for growth, but I couldn't tell him that back then. I'm not sure why, but I felt this... atmosphere that Mr.Murakami wouldn't let me speak out. (laughs)

I always aim for a glamorous finish when painting figures. That's why I use white, red, pink, etcetera for the base coat of my paintings. But Mr.Murakami starts with a black surfacer. If the prime coat is painted using dark colors, such as black, it's impossible to get that vivid brightness no matter what you paint over it. The result is this dull, saturated mono-tone finish. I eventually advise Mr.Murakami that he should sometime use white as a base coat, especially if you want to accentuate that specific

part of the figure. While speaking with him, I somehow knew he would not listen to me. I could tell he had a strong persistency in his preferred painting style. He was stubborn, in a good way, of course.

I don't know much about painters living outside Japan, but I feel that European figure painters strongly influenced Mr.Murakami. The way he builds up the light tones while leaving some of the shadows untouched. With this method, you end up using white as your brightest highlight color. However, in Mr.Murakami's works, the texture of the highlights is so well expressed that each highlight has its unique tone making them appear more natural.

As I mentioned earlier, I like finishing figures with some glamourousness. But I do alter my style depending on the subjects I paint. But Mr.Murakami doesn't. He paints cute little cartoon characters the same he would paint a realistic historical figure. This should cause some confusion and uncomfortableness for the viewers, but it doesn't. The finish might not be what the original sculptor intended, but it still looks natural. I still sense that luxuriance within his gloomy, dark, and realistic style.

Can I paint the way Mr.Murakami paints? Maybe, but that's not something I would like to do. (laughs) We each have our own distinctive styles. I am sure I do not influence Mr.Murakami, nor am I by him. If I had to venture a guess, I would say that my work is more appreciated by women, while Mr.Murakami's paintings are more tailored toward the male audience.

田川弘
1959年出生，居住在愛知縣，為人物模型塗裝界無人不知無人不曉的大師。著作有『＊PYGMALION令人心醉惑溺的女性人物模型塗裝技法』、『＊對虛像的偏愛』（＊繁中版 北星圖書出版）。

Hiroshi Tagawa is a world famouse figure painter from Aichi perfecture. Born in 1959, he is the author of "PYGMALION" anthologies from Dainihon kaiga.

村上圭吾
人物模型塗裝筆記

作　　者　大日本繪畫
翻　　譯　黃姿頤
發　　行　陳偉祥
出　　版　北星圖書事業股份有限公司
地　　址　234新北市永和區中正路462號B1
電　　話　886-2-29229000
傳　　真　886-2-29229041
網　　址　www.nsbooks.com.tw
E－MAIL　nsbook@nsbooks.com.tw
劃撥帳戶　北星文化事業有限公司
劃撥帳號　50042987
製版印刷　皇甫彩藝印刷股份有限公司
出 版 日　2023年7月
I S B N　978-626-7062-66-1
定　　價　480元

如有缺頁或裝訂錯誤，請寄回更換。

MURAKAMI KEIGO NO FIGURE PAINT NOTE
© KEIGO MURAKAMI 2022
Originally published in Japan in 2022 by DAINIPPON KAIGA
CO.,LTD.,TOKYO.
Traditional Chinese Characters translation rights arranged with
DAINIPPON KAIGA CO.,LTD.,TOKYO,through TOHAN
CORPORATION, TOKYO
and KEIO CULTURAL ENTERPRISE CO.,LTD., NEW TAIPEI CITY.

國家圖書館出版品預行編目(CIP)資料

村上圭吾人物模型塗裝筆記／大日本繪畫作；黃姿頤翻譯.
-- 新北市：北星圖書事業股份有限公司, 2023.07
　　96面；　21.0×29.7公分
　ISBN 978-626-7062-66-1（平裝）

1.CST：模型　2.CST：工藝美術

999　　　　　　　　　　　112001913

官方網站　　　臉書粉絲專頁　　LINE 官方帳號

Special thanks

木城幸人	Max Factory
Entaniya	宇津木千響
小野正志（Hot Lens）	頑途models
Eduardo Fernandez	LIFE miniatures
Histone	Big Child Creatives
吉岡和哉	Reina Roja miniatures
MAman	karol rudyk art
田川弘	Cerberus Project
SaiSo（齊藤壯平）	袁星亮
藤本圭紀	左手工房
klondike	Aradia Miniatures
小抹香Ke	Pedro Fernandez Works
大畠雅人	Kingdom death
figufigu	GARAPAGOS miniatures
	Nocturna Models
	（排名不分先後並省略敬稱）

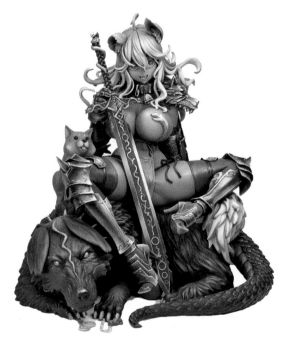

CP Girl(ケルベ子)　2022年製作　無比例　Cerberus Project